GUIDE TO
CLIMBING PHOTOGRAPHY

GUIDE TO
CLIMBING PHOTOGRAPHY

Jeff Achey

STACKPOLE
BOOKS

Published by
STACKPOLE BOOKS
5067 Ritter Road
Mechanicsburg, PA 17055
www.stackpolebooks.com

Printed in China

10 9 8 7 6 5 4 3 2 1

First edition

Cover design by Caroline Stover
Cover photo by the author—Topher Donahue on the Diamond of Longs
 Peak, Rocky Mountain National Park, Colorado
All photos by the author, unless otherwise credited.

Library of Congress Cataloging-in-Publication Data
Achey, Jeff.
 Guide to climbing photography / Jeff Achey.
 p. cm.
 ISBN 0-8117-2728-9 (pbk.)
 1. Photography of mountains. 2. Mountaineering. 3. Photography—Cold weather conditions. I. Title.
 TR787.A24 2000
 778.9'36143—dc21

 99-30219
 CIP

To my parents, John and Virginia,
for letting me climb, giving me my first camera,
and encouraging me in everything

CONTENTS

FOREWORD .. viii

INTRODUCTION ... xi

PART I: GEAR ... 1
 Chapter 1 Cameras for Climbers 2
 Chapter 2 Lenses and Their Effects 12
 Chapter 3 Film and Accessories 22
 Chapter 4 Climbing Accessories for Photographers 34

PART II: BASICS ... 41
 Chapter 5 Light and Exposure 42
 Chapter 6 Composition ... 56
 Chapter 7 Shot Types .. 65

PART III: GOING VERTICAL .. 77
 Chapter 8 Camera Care in Extreme Environments 78
 Chapter 9 Rigging ... 83

PART IV: SHARING YOUR WORK 95
 Chapter 10 Telling the Story 96
 Chapter 11 Selling Your Photographs 101

CONCLUSION .. 104

RESOURCES .. 106

FOREWORD

I began my photo career under the tutelage of a wilderness photographer who carefully planned his artistic efforts around the magic hours of sunrise and sunset. As I ventured farther into adventure photography, however, I quickly realized that the magic hour was a luxury that no longer applied. Good climbing photography requires being ready for the magic *moment*. I had to figure out where the best action would occur, and how to get there first.

Some of the best mountain photos have been captured by amateurs with a point-and-shoot camera whipped out of an easily accessible waist pouch in reaction to some stunning natural occurrence. Yet these occasional triumphs are hard to repeat. Point-and-shoots have optical and functional limitations that soon lead the photo enthusiast into the confusing world of film, SLR equipment, and composition. At this point, a little instruction can help.

I first met Jeff on a chilly morning at the base of the sheer 2,000-foot east face of Longs Peak in Colorado. He planned to solo to the top via an easier route and rappel down to photograph us from above. Parting ways with Jeff, my partner and I, feeling slightly competitive about "our" crag, raced up the route with a "let's see if this guy can keep up" attitude. Near the top, with the face now shrouded in ethereal fog, we heard the faint sound of a clicking shutter capturing the magic moment.

Thus began a long friendship of many shared adventures, during which time Jeff spent five years reviewing images from the best climbing photographers as *Climbing* magazine's photo editor, before branching away as the magazine's prolific contributing editor of both photos and text. He has an insider's knowledge of the industry and has articulated the complexities of climbing photography in clear, concise language.

Read his book and then spend some time thinking, living, and dreaming photography. Give your camera equal place next to rock shoes in your pack. After a few hundred rolls of film, capturing the magic moment will become much less elusive.

Kennan Harvey
Durango, Colorado

Kennan Harvey has climbed from Yosemite to the Adirondacks, Patagonia to the Karakoram. His adventure photography appears everywhere.

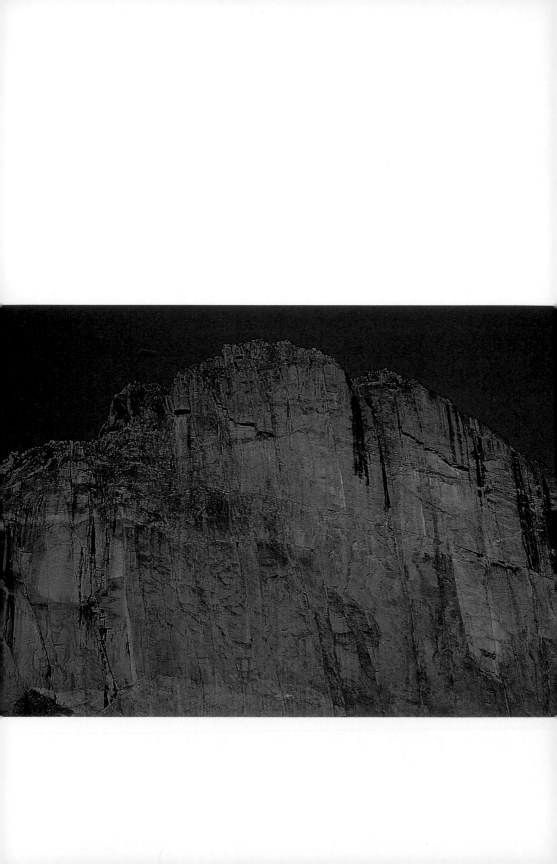

INTRODUCTION

Climbing is the world's most beautiful sport. Poets speak of the view from the mountaintop, but for the climber, the spectacle below is even finer: a dance framed by air, set above wild backdrops of desert canyon or glacial cirque. At the crags and in the camps and mountain towns there is a colorful lifestyle, diverse as the rock, linked by a common thread and image-rich as climbing itself.

A climbing photographer is surrounded by great themes: nature's beauty and power, courage and teamwork, the fall of man. It's easy to come home with good pictures.

Climbing is so naturally photogenic that it turns climbers into photographers. Yet at the same time it makes us complacent. Everyday subjects demand all the skill and creativity a photographer can muster, but when a friend is pinned to an overhanging rock wall or cooking breakfast below a looming ice peak, many of us are likely to be satisfied with a careless snapshot. Imagine the results when you apply more skill and creativity to such photogenic subjects.

I've shot climbing for more than twenty years, as an amateur and a pro, but if this book is helpful it's less because I'm particularly talented than because I've been around talent. As photo editor at *Climbing* magazine, I was paid to be critical of the best climbing photography and was fortunate enough to eavesdrop on photographers whose skill far exceeded mine. I got to know their style and some of their secrets and compared their work side by side and with my own struggling attempts. I heard their frustration when good images were sent back or the money

Opposite: **The Diamond, Longs Peak, Colorado.**

was bad, which was usually. To these people—Greg Epperson, Ace Kvale, Kevin Powell, Kevin Worrall, Bill Hatcher, Kennan Harvey, John Burcham, Jim Thornburg, Michael Kennedy, Beth Wald, Brian Bailey, Galen Rowell, Simon Carter, Stephan Denys, Peter Mathis, Uli Wiesmeier, Heinz Zak, and far too many others to list—I owe a great debt. My work improved tenfold, and now I hope to pass some of that on. If nothing else, reading this book will get you thinking critically about your photographs, which is probably the most important step toward improving them.

Light, form, and color—and the photographic equipment that captures them—are complex. It's a big challenge to manage everything that stands between a scene in nature and an image on film. Still, once you break down the chaos into specific technical problems, simple solutions often emerge. A snapshot won't show how a mountain seems to loom over your camp, for example, but if you back up and shoot the camp and peak with a telephoto lens, the effect is vivid. If you want to draw attention to one climber among several at a busy sport crag, throw the clutter out of focus by opening up the lens aperture. You'll find specifics like these throughout the book.

Other problems in climbing photography are logistical. Moving around on mountains and crags is strenuous, and you need a light and durable equipment system that still gives you photographic control. Your camera gear must function in extreme environments. Equipment choices will not be the same as for a sport photographer who specializes in tennis or golf.

Climbing photography can require dangerous technical rigging, and you must know what you're doing with ropes. This book is not a how-to-climb book. Any active outdoorsperson can shoot bouldering and other close-to-the-ground climbing, but to be a full-fledged climbing photographer you must first be an expert climber. Even if you climb, rigging a big vertical shoot may exceed your technical expertise. The basics are covered here, but it is assumed that you already know how to rappel a fixed rope and tie a clove hitch. If you need more technical climbing instruction, there are plenty of excellent sources out there, the most important of which is experience.

This book also discusses what to do with your photography once you get it. Great climbing photos aren't much use if they're stored in boxes in the basement or buried in three-hour-long slide shows

that put everyone to sleep. Properly managed, your photographs can win you fame and influence among your friends and can even fund climbing trips.

So if you've gotten this far, you know what's covered in the rest of the book and whether it can help you. Let's get on with it.

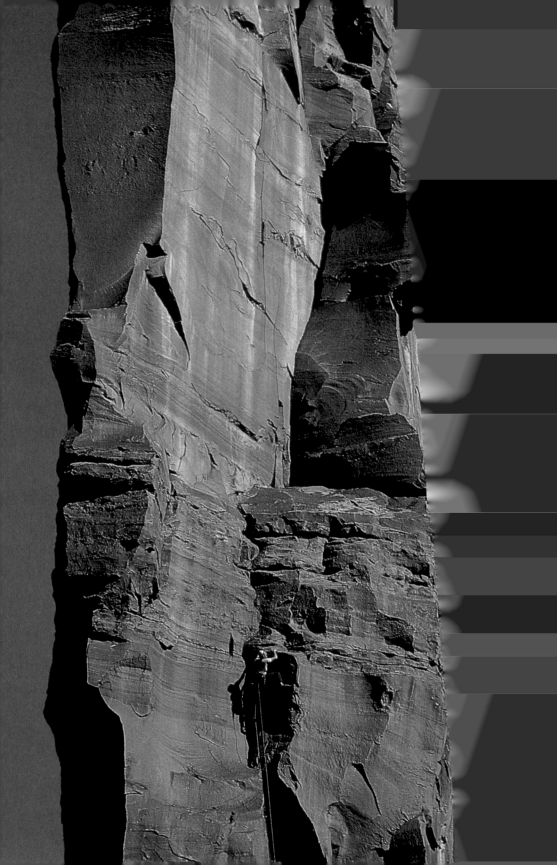

GEAR

Good camera gear will not automatically make you a successful climbing photographer. Poor gear, however—or a poor understanding of good gear—will guarantee poor results.

Good equipment isn't necessarily the most expensive. The key to getting set up for climbing photography is to buy sturdy equipment that can withstand extremes in temperature and climate, and that gives you good control over your exposures in the high-contrast light of the mountains and crags.

Exposure control isn't much good, however, if you don't use it well. Even if you sort out your lights and darks, the same controls also determine depth of field. Your lenses, too, have multiple effects, such as emphasizing height or compressing your foreground and background. That said, the rules are pretty simple, and the first one is to get the right equipment for the job.

Opposite: **Kennan Harvey on Zeus Tower, Canyonlands National Park, Utah.**

CHAPTER 1

CAMERAS FOR CLIMBERS

Camera equipment is expensive. When I'm on a wall climb, the relatively simple camera and lenses I carry are worth as much as my entire high-tech aid rack. On road trips, my photo gear is worth more than my car. Often, you have a once-in-a-lifetime chance to capture the events unfolding in front of you. If a camera fails or performs poorly, the shot is lost. In the mountains, you usually can't come back. You need gear that does exactly what you want and is built to last.

The most basic component is the camera itself, the body. A camera body will accept many different lenses that are bought separately (see the next chapter).

The photos you see in most climbing posters, slide shows, and climbing magazines—even mountaineering features in the pickiest magazines, such as *National Geographic*—are almost all shot with the same basic type of camera body: 35mm format single-lens reflex (SLR). *SLR* refers to a camera that allows you to see and focus through the single working lens of the camera, using a reflex mirror system that folds out of the way when you trip the shutter. Before SLRs, some cameras had double lenses—one for the photographer's viewing, and one for the film.

A 35mm SLR camera uses roll film that is 35mm wide and exposes a 36×24mm image. The sprocket holes that advance the film fill out the space between the 24mm image and the film edge. This image size was long considered too small for serious photography, but that's no longer the case thanks to modern fine-grained films.

Larger film formats—such as the medium formats of 6×4.5cm, 6×6cm, and 6×7cm, or the 4×5-inch large format—are still de rigueur in the fashion studio or for large landscape prints, but magazine work

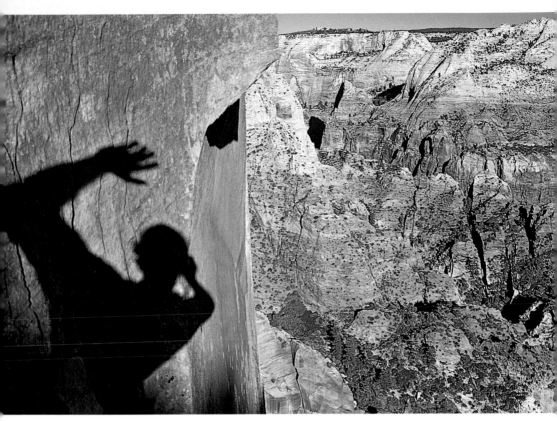

Self-portrait, Zion National Park.

exerts a lot of influence on adventure photography trends. Magazine printing can capture most of the detail in a good, sharp 35mm image, but not much more. The extra image quality you get with bulky and expensive medium- or large-format equipment is mostly lost in publication. Cameras with film formats smaller than 35mm aren't much smaller overall, and the tiny image size seriously compromises your results. If you choose to shoot on a different format, most of the information in this book will still apply, but the camera equipment sections stress the 35mm format.

The original 35mm cameras were not SLRs but used viewfinder or range-finder focusing systems coupled to the camera lens. The best range finders were favorites of war correspondents; had razor-sharp, interchangeable lenses; and would be excellent tools for the modern

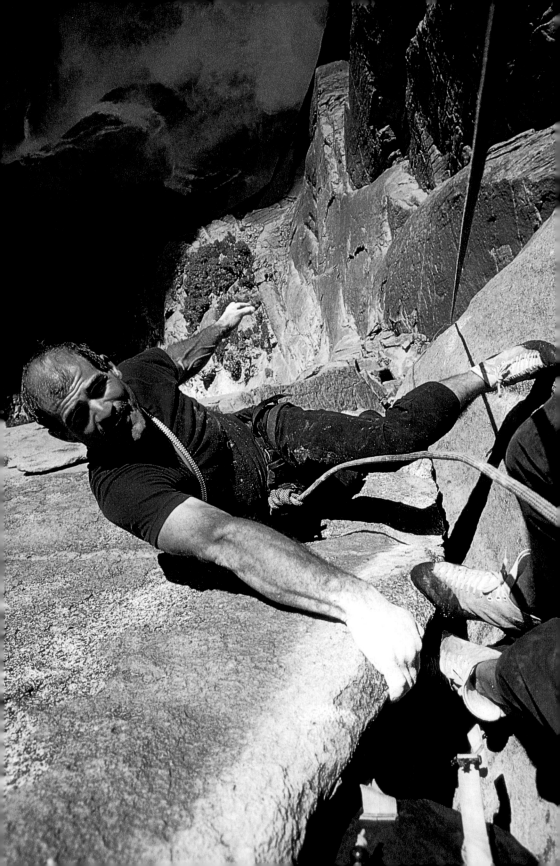

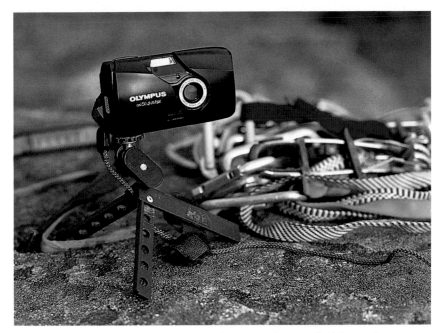

This 6-ounce Olympus pocket camera has served me well. It has a sharp, fast (f/2.8) lens, and a focus and exposure lock that lets me trick the camera into allowing a bit of manual control. The tripod weighs an ounce and a half, can strap to a ski pole or ice ax, and folds down to 4 inches.

climbing photographer. This style of camera, however, is all but extinct, and those that remain are expensive prestige trinkets or collector's items. Now, most non-SLR cameras are plastic autofocus jobs meant for casual snapshooting.

POCKET CAMERAS

Many super-compact cameras can produce good pictures and, lacking the bulky mirror system of an SLR, fit in a shirt pocket. Unfortunately, the autoexposure systems are simple, designed for forgiving print film (which can be four f-stops under- or overexposed and still yield good results) and offer no manual options for dealing with the tricky

Opposite: Climbing is one thing; shooting photographs of climbing is another. Once photography is in your blood, though, you'll want a camera you can bring along even when you're going light, such as on this climb next to Yosemite Falls.

metering situations climbers encounter, such as ice and snow scenes. If you're shooting slide film—standard for serious climbing photographers—you definitely need more exposure control.

No pocket camera can take the place of a good 35mm SLR, but I do own one and take it places I'd never take my SLR, like up on hard rock-climbing leads, on mountain runs, or to rough evenings at the pub. They're handy when you need something super-light. Non-SLR 35mm cameras run from $10 disposable supermarket jobs to $3,000 museum pieces with interchangeable lenses, but most are in the $100 to $300 range. The midrange pocket cameras come in two basic types: those with fixed-focal-length lenses (usually 28 or 35mm), and slightly less compact zoom lens models.

The fixed-lens cameras are fairly "fast," meaning they don't require much light. Pocket zooms, which give you a choice of two or more focal lengths, say 35mm and 70mm, are much slower. Typically, their maximum apertures are f/8 or smaller in telephoto mode, and if loaded with fine-grained slide film, they struggle badly in low light.

You'll find that pocket cameras deliver a shocking

Left: **I clipped a pocket camera to my lead rack and took this shot of Mark Synnott at our hanging camp on the Painted Wall in the Black Canyon of the Gunnison, Colorado.**

Opposite: **On alpine terrain you can easily carry a light SLR in your pack. I used a manual Nikon FM2 with a midrange zoom lens for this shot of Irene Boche in the Italian Dolomites.**

number of fuzzy pictures. Poor optics don't account for this; even the precision cameras aren't immune. The two main causes are slow shutter speeds needed by the slow lenses of pocket zooms and autofocus problems. Avoid the shutter speed problem by avoiding pocket zooms. In light where a fixed f/2.8 lens lets you shoot at an easily hand-holdable 1/60 of a second, a typical pocket zoom will be shooting at 1/8 of a second or slower. Since all the controls are automatic and "secret," you'll never know these settings unless you guess them from your blurred photos. Fixed-lens cameras have only one lens perspective, but the results are much more likely to be crisp. Get a camera with a lens f/3.5 or faster, and shoot a slightly faster film than you would with your SLR.

The autofocus problem plagues zoom and fixed-lens pocket cameras alike. The main cause is the camera's inability to recognize subjects that aren't in the center of the frame—a serious drawback for a camera you can't focus manually. Make absolutely sure that any pocket camera you buy has a focus lock. Typically, you'll center your subject, then half depress the shutter button to lock the focus while you recompose the shot. Read the instructions and burn a few practice rolls to make sure you've got the hang of it. Some pocket cameras have an infinity lock, a helpful manual control that guarantees sharp focus for distant objects.

On most pocket cameras, the focus-lock procedure also locks the exposure, and it's the only way to get any exposure control. Lock on a brighter object to underexpose your film or on a dark area to brighten it. Obviously, this is guesswork, and it can be a problem if you're trying to trick the light meter and the autofocus at the same time. Here, you'll need exposure compensation controls or manual override to intentionally over- or underexpose the film. To get these features, you'll need to take a leap up in price—spending as much as you would for a good SLR.

Look for these features in a pocket camera:
- Minimum lens speed of f/3.5
- Tiny size (otherwise, it's better to carry a light SLR)
- Some exposure control—exposure lock, exposure compensation, or manual override
- Manual focus (hard to find), autofocus lock, infinity lock

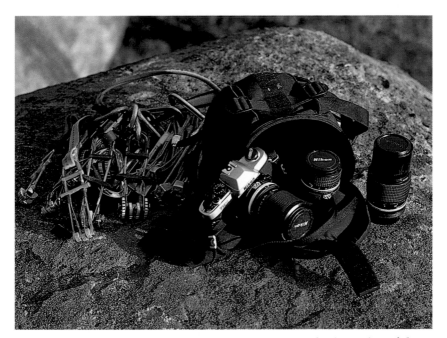

The camera body in this photo is an FM10, a 15-ounce plastic version of the tried-and-true FM2, which weighs 1 pound 4 ounces. Add an all-plastic zoom lens and I save almost a full pound off my normal manual camera system with no loss in function or image quality. Still, this Nikon looks so chintzy I seem to purposely abuse it, but so far it's still working. The lenses are a 35–105 zoom (on the camera), a 24mm f/2.8, and a 200mm f/4—my most-used combination.

THE SLR BODY

Your workhorse camera will be a 35mm SLR. A good SLR system is like an alpine-climbing wardrobe. Starting with one basic outfit, you layer on and off, depending on the conditions. An SLR body is the core of your system and can accept dozens of different lenses, from super-wide "fish-eyes" to astronomy-style telephotos.

Pay special attention to the size of the camera. Its bulk and weight will usually decide whether you'll take it along on a climb. Half the battle of good amateur climbing photography is having a camera handy when you encounter a once-in-a-lifetime scene.

The next thing to consider when choosing a body is electronic automation. Cost isn't the main issue here—you can buy a camera with automatic exposure and focus for the same price as one with manual controls. Automation will affect the camera's reliability in harsh conditions, your ability to do special flash effects, and your shooting style.

If you're just getting into photography, consider buying a sturdy manual camera that requires battery power only for its light meter. Most of the photos in this book were taken with one of these, the Nikon FM2. Such cameras are less likely to fail than ones that rely completely on battery power, and they'll force you to learn photography basics. A fully automated SLR might give you better results at first, but such a camera is like a car with automatic transmission. Your driving skills will always be lacking unless you know how to work a clutch and shifter. Only by working directly with apertures and shutter speeds will you learn how to manage important effects such as apparent movement and depth of field. Later, if you want to trade up to a good electronic SLR, your manual camera makes a bombproof backup and will remain your camera of choice in many situations.

That said, electronic cameras rule the pro market. They feature built-in motor drives that advance the film automatically or allow you to fire off multiple frames per second. You can—and should—get an auxiliary motor drive for your manual camera, but the built-in ones are lighter. Electronic cameras have computerized metering systems that not only nail good exposures in difficult lighting but also allow fancy through-the-lens metered flash effects that are impossible with a manual camera.

Autofocus is another electronic feature. Even the best SLR autofocus systems are prone to errors and must be used selectively, but they're a definite plus, especially when the action is fast.

A significant advantage of an electronic camera—and this is the clincher for many photographers—is through-the-lens flash metering. With an electronic camera and a good speedlight, you can do subtle fill-flash and special effects to create the appearance of motion that you can't do with a manual setup.

If you go electronic, avoid the low-end all-plastic SLRs. "Amateur-pro" models like the Nikon N90 are widely used by adventure photographers and have an excellent track record. If you go manual, look for something compact and durable, and make sure it will accept a motor drive.

POCKET vs. MANUAL vs. AUTO: PROS AND CONS

Pocket Camera Pros
- Super-compact
- Featherweight
- Inexpensive
- Built-in flash

Pocket Camera Cons
- Little or no exposure control
- Unsophisticated autofocus
- Extremely limited lens options

Manual SLR Pros
- Rugged
- Good for learning
- Works if batteries die
- Good in extreme cold
- Light and small
- Excellent backup camera

Manual SLR Cons
- Poor for quick snapshooting
- Flash photography difficult
- Add-on motor drives are heavy
- No fancy features such as autobracketing

Electronic SLR Pros
- Autofocus good for fast action
- Point-and-shoot metering options, as well as full manual
- Best for flash effects
- Motor drive allows sequences and no-wind shooting

Electronic SLR Cons
- Bulky
- Can be delicate
- Top models are expensive
- Can fail in the cold
- Runs through expensive batteries

BUYING TIPS

There are some tricks worth knowing if you're buying camera equipment. I mail-order most of mine from ads in the back of magazines such as *Popular Photography.* This isn't pleasure shopping—you have to know what you want and be ready to deal with a pushy New York City salesperson who will spring confusing information on you, such as that it costs $50 more than the advertised price for the U.S. warranty. You'll be rewarded for your perseverance by paying about half what you would in a local store, plus postage.

Check out used-gear brokers, such as KEH Camera in Atlanta, who will also buy equipment you no longer want. Used gear is graded, and I buy only the lower grades. The prices for "like new" or "excellent" equipment aren't much less than those for new, and the differences are mostly cosmetic.

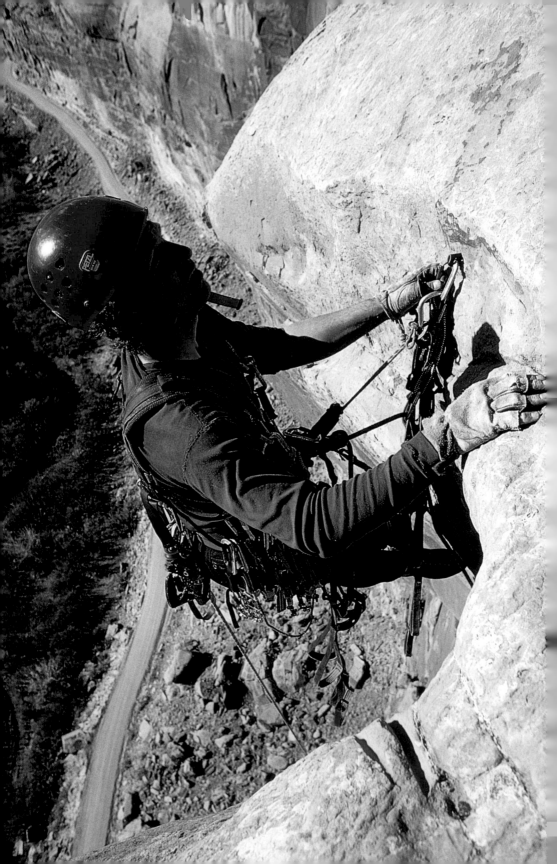

CHAPTER 2

LENSES AND THEIR EFFECTS

The choices in lenses—wide-angle, super-telephoto, zoom, macro—are mind-boggling, and the prices are shocking. What should you buy, and what should you bring for which climbs? You'll be doing a balancing act among focal lengths, speed, sharpness, weight, price, and durability.

First, a word on price. If you have any self-respect as a photographer or any aspirations of publishing your photos, don't buy cheap lenses. You get what you pay for. It's better to own one good lens than five second-rate ones. Beware of any lens that's not made by the manufacturer of your camera, or that's offered at a bargain price. Cheap zooms are the worst of all lenses—no matter how good your subjects and compositions, a sheet of slides taken with a cheap zoom will spend about one second on an editor's light table before going into the reject pile. *Cheap*, of course, is a relative term; prices vary according to lens types. A "cheap" f/1.2 50mm lens costs about the same as an expensive f/1.8 50mm. A long telephoto lens costs ten times as much as a normal lens. The only way to judge is to compare the prices of identical lens types.

FOCAL LENGTH

Focal length is the most basic lens specification and refers to the angle of view: how much of the scene a lens projects onto the film. Lenses vary from wide-angle—those that take in a broad view, rendering it small on the film—to telephoto—lenses that take in only a small portion of the scene and magnify it.

Opposite: **Your lens should match your purpose. Here, I used a 24mm wide-angle to make this 500-foot wall near Moab look tall, while filling the frame with Jason Laflamme's gear, ropes and stoic big-wall expression.**

The lightest, smallest lenses are "normal" focal length, which is 50mm for a 35mm camera. Often, such a lens comes with your camera. To effectively shoot climbing, you'll need other lenses, too—enough to cover at least the 28 to 100mm range. Cover the focal lengths from 20 to 200mm and you're set for almost any type of climbing shot except super-telephoto. You can buy three to six fixed-focal-length lenses to cover this range, or opt for zoom lenses.

Classifying lenses from wide-angle to telephoto might lead you to believe that the most important effect of focal length is capturing a certain view—expansive scenics or a zoomed-in look at a faraway subject. In fact, wide-angle mountaintop panoramas are usually disappointing, and a telephoto close-up might be inferior to what you'd get if you roped down and got closer to the climbers. A more important effect of focal length is what it does to the relationship between subject and environment. Your lens choice helps you suggest height and steepness, determines your possible depth of field, and changes the relative size of subjects in your photo.

Wide lenses render close objects relatively large and distant objects small. Hence, when you shoot straight down with a 24mm wide-angle lens, an approaching climber (once he's close enough) will appear large in the frame and the trees on the ground will appear tiny and far away, an effect that gives a great feeling of height. Along with this effect, however, may come unwanted distortion. Your friend's nose will appear disproportionately large compared with the rest of his face—not a flattering effect. A hand reaching up toward the camera will look larger that the head below it. Distortion increases as the subject gets closer to the camera. Very wide lenses may produce a "Silly Putty" effect in the corners of the frame. This can be either distracting or useful. I recall one shot taken by the master climbing photographer Greg Epperson of Jo Whitford grunting up a strenuous, body-width crack. Epperson's lens distortion exaggerated Whitford's grimace into a comical caricature of the suffering unique to that type of climbing.

For flattering portraits, an 85 to 100mm lens is best. As you back away to fit your subject in the frame, you eliminate the close-up distortion you get with a wider lens. In fact, a long lens "compresses" any scene, making the background look much closer than it does in life. If you're shooting straight down on an approaching climber, for example, a 100mm lens will make the ground look closer, perhaps not the effect

Typical wide-angle distortion. In the left shot, taken in the Shawangunks of New York, the climber's hands appear huge, while the ground—only about 80 feet below—appears distant. The right shot, in Utah's Canyonlands, elongates the climber's legs and makes the vertical wall appear less steep.

you want. Fortunately, long lenses have a narrow field depth (more on this later), and that too-close background may be out of focus, restoring the off-the-deck look you desire.

Compression is one of a long lens's most useful effects. Shot straight on with a telephoto, mountain faces look steeper, since the faraway summit is brought proportionately closer to the base of the face, altering the apparent angle. You'll also compress the foreground-background distance, making the mountain or cliff appear closer. Instead of just stepping over to the cook area to take a picture of your tent at base camp, walk back a few hundred feet and shoot with a long lens. The mountain will loom over camp, huge and steep—an effect that might better convey the emotion you felt before the big climb.

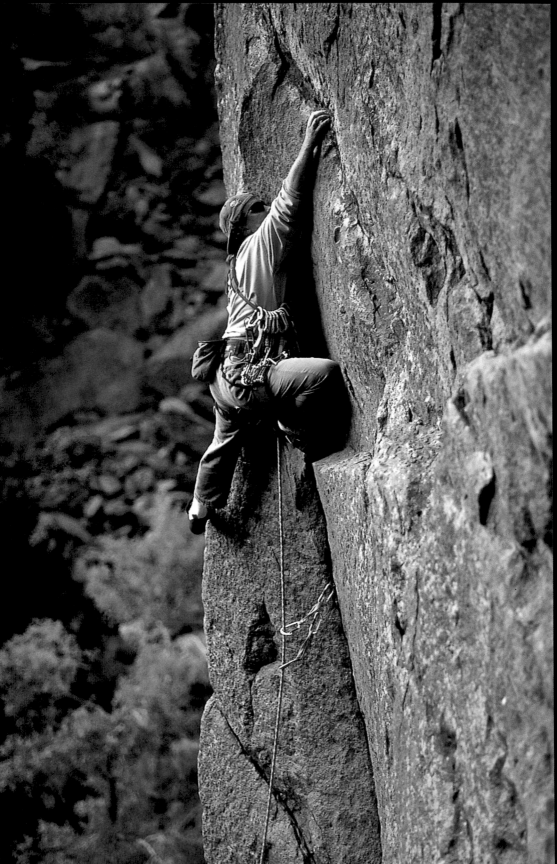

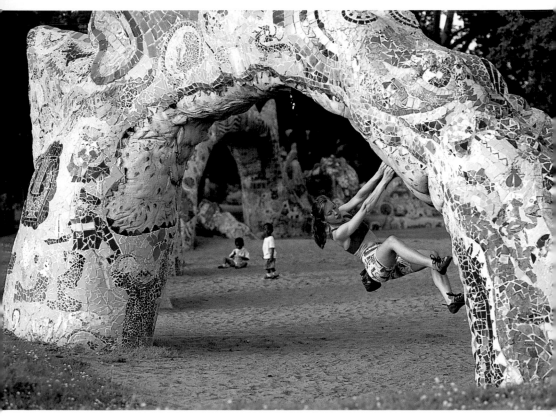

Medium telephoto shots. *Above:* **In this shot, taken in Dragon Park in Nashville, the lens compressed the receding coils of the mosaic dragon and rendered the kids large in the frame and in soft focus.** *Opposite:* **In this shot, taken in Eldorado Canyon near Boulder, Colorado, there's sharp focus only on the climber. The 135mm lens let me crop out the road and other cliffs to keep the background relatively simple, render it in soft focus, and disguise the fact that the climber is only about 20 feet off the ground.**

SPEED

This term describes how much light a lens can gather. It refers to how wide the lens can open, but it's called speed, somewhat confusingly, because the size of the lens aperture determines how fast a shutter speed you can use. F-stops, the numbers used to describe lens speed, are confusing in themselves, since they run counterintuitively—a smaller number means a wider aperture that admits more light—and in geometric series rather than simple fractions like shutter speeds.

Designed to be useful in the old days when photographers had to do manual calculations that we can now blissfully ignore, these user-unfriendly f-numbers are probably the biggest reason why beginners find photographic exposure a daunting topic. Once you get used to the jargon, however, the principles are simple.

The wider the maximum lens aperture, the "faster" the lens. An f/2.8 lens is twice as fast as an f/4 lens, which is twice as fast as a lens with a maximum aperture of f/5.6. An f/1.2 lens is extremely fast, whereas an f/8 lens is considered slow. The lens aperture is adjustable; most lenses will "stop down" to f/16 or narrower.

Normal (50mm) lenses are naturally fast, while even the most expensive wide or telephoto lenses are slower. Fast lenses allow you to shoot without a tripod in dim light. As a side benefit of purchasing a fast lens, you may also get superior sharpness, since lens makers use their best glass, coatings, and manufacturing tolerances on their fast lenses. For any given focal length, however, the faster the lens, the heavier and more expensive it will be.

If you're on a budget or need to minimize weight but want one fast lens for low-light shooting, use your standard 50mm. A typical low-end 50mm is f/1.8—faster than the fanciest $2,000 pro zooms—but costs under $100.

Lens aperture also affects depth of field, the distance range of in-focus objects in your shot. Fast lenses, used wide open, have a narrow range of focus. This can either throw half your intended subject out of focus or isolate it from a cluttered background. See chapter 6 for tips on how to manipulate this important quality in your pictures.

ZOOM LENSES

Once avoided because of the inferior image quality that accompanied more complex optics, variable-focal-length zoom lenses have improved and are now standard in climbing photography. Advantages are obvious: You carry fewer lenses and can change focal length without risking dropping a lens while hanging on a rope. With zooms you can do precise in-camera cropping to get just what you want in your picture and nothing more.

Opposite: **Long telephoto lenses are nice for capturing the action when you just don't want to get on the wall again. This shot of the Diamond in Rocky Mountain National Park was taken from a vantage point reached by moderate hiking.**

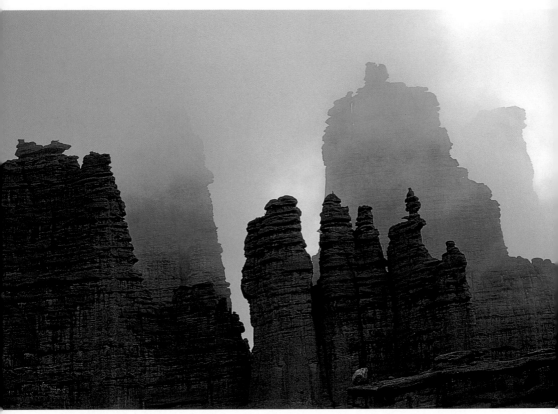

Utah's Fisher Towers in cloud. You can see the compression effect of a long telephoto lens—the foreground and background towers are nearly half a mile apart.

Drawbacks are that, size being equal, a zoom is slower than the fixed lenses it replaces, and it may not be quite as sharp. Buy carefully, and be especially suspicious of lenses that zoom much more than 2X: 24–50mm and 100–200mm zooms are safer bets, for example, than a 24–200mm.

Choosing zooms is complicated. Large and heavy zooms are no fun to carry, but these qualities come along with focal range and lens speed. Zoom lenses typically have variable maximum apertures—for example, f/4–5.6—and are faster in their midrange than in telephoto or wide-angle mode, which makes comparison even more confusing.

Through trial and error I've ended up with several overlapping zoom and fixed lenses that I combine differently, depending on the shoot. If I'm carrying my manual SLR and just one lens, I take a 35–105mm f/3.5–4.5, a versatile do-it-all lens. For a two-lens system for lightweight backpacking, I like a 24–50mm paired with an 80–200mm.

Many pro climbing photographers use super-fast (f/2.8) zooms. As you go up in lens speed, however, two other things follow: price and weight. You may pay six times as much for an f/2.8 zoom as for an equivalent f/4–5.6, and whereas a 70–210mm f/4–5.6 is just bigger than a beer can, a comparable f/2.8 approaches quart thermos size. Even if price is no object, a super-fast zoom may be so massive that you always end up leaving it on the ground, in which case it won't improve your photographs.

LENS SYSTEMS

A good, functional bare-bones kit for serious climbing photography is three lenses—a fixed 24mm wide-angle, a 35–105mm zoom, and a fixed 200mm—plus a good 2X teleconverter (which will turn your 200mm into a 400mm). With this assortment, you have good wide-angle power, the full normal range in one lens (which you can carry alone on climbs), and adequate telephoto power.

The ideal do-it-all lens for on-rappel shooting would be a tack-sharp 24–100mm f/2.8, but I've yet to see such a lens. A good setup for rigged shoots consists of two fast (f/2.8) zooms—one 20–35mm or 24–50mm wide-angle, and one 70–200mm telephoto. It's wise to bring one electronic body and one manual backup. Even if your electronic camera doesn't fail, you'll have twice the film loaded when the action starts, which can save the day.

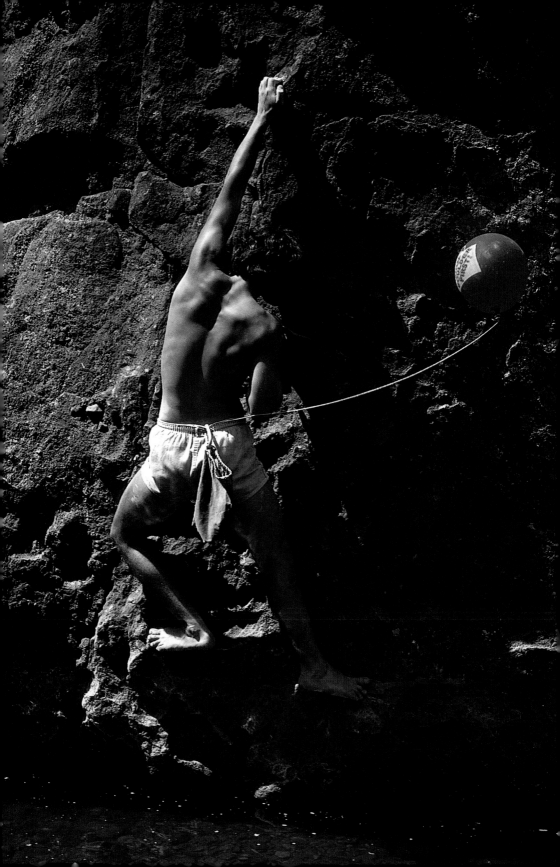

CHAPTER 3

FILM AND ACCESSORIES

Besides camera and lenses, your kit will include a few more accessories, the most important of which is film.

FILMS

The film in your camera is a strip of celluloid treated with chemicals that react when exposed to light. After this reaction—the exposure—the film must be chemically treated—developed—to produce the final film image. For "diapositive" slide film, that's the end of the process. For print film, the lights, darks, and colors of the developed film image are reversed, and you make a positive print by shining light through the negative onto photographic paper.

The shape of the image registered on the film is a function of the lens; the colors and brightness are a function of the film chemistry. Black-and-white films are sensitive only to the brightness of the light, whereas color films also register the color spectrum. Keep in mind that this is an artificial process. Different chemicals on the celluloid react with different wavelengths of light. There is no direct transmission of color onto the film. The resulting colors aren't what nature sent through the lens, but rather a palette that a team of film designers created.

Films are given an ISO (International Standards Organization) number, which specifies their sensitivity to light. Slow films, ISO 25 to 50, need a lot of light for proper exposure; fast films, ISO 200 to 1500, need much less light to make an image. In general, the slower the film, the finer the grain of the chemical crystals, the sharper the image, and the richer the colors.

Opposite: **Keep it simple; go light.**

Most climbing photographers favor slide films for the majority of their work. These are inexpensive to process and require no printing, and the images can be used immediately for slide shows or magazine submissions. E6 chemistry is preferred, since Kodachrome films must be sent away by mail to just a few specially approved labs. Films are always getting better. Currently, the most popular slide film among climbing photographers is still the longtime favorite Fuji Velvia (ISO 50).

Black-and-white is a beautiful, elegant medium that can bring out subtle tones and textures lost in the garish world of color. The printing, however, requires darkroom skills that are beyond our scope here. Kodak T-Max 100 (ISO 100) and the old standby Tri-X 400 (ISO 400) are good black-and-white print films.

Most climbing photographers, myself included, don't use color print films, favorites of both the casual snapshooter and the high-end printmaking photographer. When I want to make a color print, which is seldom, I take it to a shop that can do a digital scan from a slide, which costs about $15 for an 8×11-inch print.

Slide film's worst drawback is its narrow latitude, meaning that it can handle only a small range of brightness before the highlights blow out or the shadows go jet black. Print films, especially black-and-white, can handle a much greater range of brightness, giving you snow textures or shadow details you lose in color slides. Print films are more forgiving of exposure errors, since a lab can lighten or darken the image in the printmaking process.

Each film's ISO rating is a bit idiosyncratic. When I shoot Kodachrome 64, I almost always underexpose a stop to improve the color saturation. Velvia, in contrast, is comparatively overrated at ISO 50, and it doesn't need any saturation enhancement to look rich. If you're just starting out, stick to one or two types of film until you're familiar with them, then experiment.

If you under- or overexposed an entire roll of film—perhaps by forgetting to change the ISO setting when you change film types—a custom lab can "push" or "pull" it for you when it is developed. You can ask for a "snip test" on the first few frames of the film to check the developing. Pushing film—exposing it with only half the light required by its ISO number and then "overdeveloping" it in the lab—is a common technique among pros. Do this by manually setting the ISO to twice the film's rating. Make sure to tape a reminder note on each roll you plan to push.

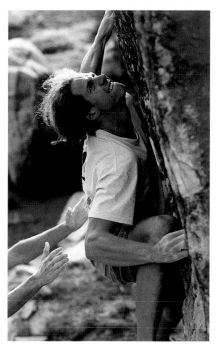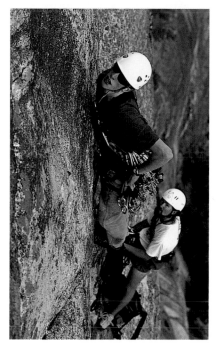

Kodachrome vs. Velvia. Don't discount out-of-vogue films. On the left, the Marlboro-man color palette of Kodachrome 64 can be just right for gritty action portraiture. With Velvia (right), you'll get better color saturation, especially in blues and greens.

Whatever film you choose, make sure that you load it into your camera out of direct sun. Dust or ice crystals must not get in. Use a lightproof changing bag (or improvise one out of a nylon jacket) if you must load film in a windy, dusty environment.

ACCESSORIES
Filters
For color photography, you don't need many filters. Three very helpful types for climbers are skylight, warming, and polarizing filters. Variable neutral-density filters are useful for mountain landscape work.

If you like to leave your camera dangling around your neck, ready in an instant to shoot, consider protecting your lens from scratches with a near-neutral ultraviolet (UV) or skylight filter instead of a lens cap. If you keep it clean, you can shoot right through this filter and replace it

when it gets scratched. For sharpest results, when you've got the time to be more careful, take it off to shoot.

Direct sunlight is almost white around midday and a nice warm yellow or orange in morning and evening. Shadowed subjects, however, are indirectly lit in all sorts of colors—green in deep forest, for example, or blue under a clear sky. Sometimes you'll want to correct for this lighting, especially the cool blue, which can turn skin tones pale.

Blue skylight is common. You won't see it because your eyes adjust automatically, but it will show up on film, most noticeably in the shadowed snowfields of mountain landscapes. A warming filter compensates for the blue of skylight. Warming filters coded 81A are subtle and don't absorb much light. Their effect is usually about right. An 81B is stronger, will cost you about one f-stop of brightness, and can give artificial-looking results.

One very powerful filter type is the polarizer, which cuts glare, boosts contrast, and deepens the blue of skies. The effect is dramatic, sometimes just what you want to take the flatness out of midday light. In the heyday of Kodachrome, you saw lots of polarized shots in magazines, but modern color films such as Velvia, with their intense color saturation, have made polarizers almost obsolete. A polarizing filter can be adjusted by aligning the filter grid with the plane of polarization of the light coming from the scene. The polarizing filter's housing spins freely, allowing you to turn the filter and block out more or less of the unpolarized light. Overpolarized shots look fake, so use these filters with restraint.

Finally, there are variable neutral-density (ND) filters, which are clear at one edge and a neutral gray at the other. These, in effect, extend the latitude of your film, so you can render certain high-contrast scenes the way they look to your eye. There are "split" ND filters, with a distinct line between clear and gray, and "graduated" ND filters, which fade gradually from clear to gray.

To use a variable ND filter, position the gray part of the filter over the bright portion of the scene, such as the glowing sky, where it absorbs anywhere from one to three stops of light. The clear portion of the filter goes over the shadowy foreground. This way, you dim down the sky, compressing the range of brightness, which allows acceptable exposure for both highlights and shadows. An excellent sourcebook on ND filter use and many other outdoor photography techniques is *Galen Rowell's Vision,* an extremely informative collection of pieces originally

Drama through polarization—rich colors and surreal sky. Polarizing filters can help ease your midday-light blues, but they make the shots look fake and seldom really satisfy. If you're using a wide-angle lens, beware of "vignetting," a darkening in the corners of the frame where the filter housing is in the field of view.

written by the pioneering adventure photographer for his column in *Outdoor Photographer.*

Lens Hoods
Direct sunlight on your camera lens will produce glare, flare, and other undesirable effects. The best way to avoid lens flare is to shoot from a camera position that's out of the sun, in the shadow of a boulder or tree. When you can't move, a metal or rubber hood that extends from the end of your lens can help keep sunlight off the glass. Many telephoto lenses come with built-in hoods. Hoods can also protect your lenses, since they stick out past the glass to take the first knocks, though some

will interfere with screw-on filters. Alternatively, shade the lens with your hand, being careful to keep it out of the picture.

Light Meters

Opinions vary about the usefulness of auxiliary light meters. Some pros swear by them; others never use them. All modern cameras have built-in light meters, but for some lighting situations, a separate hand-held meter is useful. Manual cameras usually can't meter exposures longer than a second, so for any kind of dim-light shooting, you're forced into complete guesswork unless you have an auxiliary meter. Snow or deep shadows can fool your meter, but there are tricks you can use to compensate (more on this later). A good meter is also helpful for setting up artificial-light photography. For most adventure shooting, however, you can get by with just the meter on your camera.

Flashes

Whereas just a few years ago, good artificial lighting was out of the question for most adventure photography, modern flash gear has revolutionized shooting styles. A compact variable-intensity strobe coupled to a camera that can do through-the-lens flash metering lets you shoot successfully in conditions that would otherwise shut you down. Rock climbs in dark, overhanging caves are now viable subjects, and even in bright sun, a little fill flash can bring out details in the shadowed faces of your climbers. If you're

Even a cheap flash can help you get some worthwhile snapshots to round out the day's shooting.

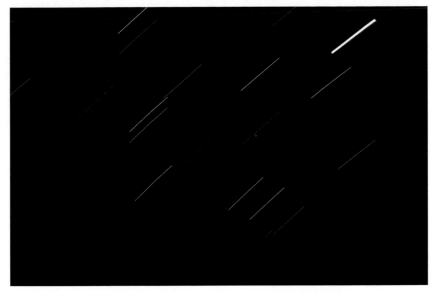

A tripod, cable release, and a little patience are all you need for night photography. Anticipate how the stars will move and try to have the streaks make sense in your composition.

going to use artificial light, get a good electronic camera and a top-of-the-line flash. A "soft-box"—a translucent balloon or box that fits over your flash—will soften the sharp shadow lines that identify fill-flashed shots and make them look artificial, but such attachments are bulky.

Tripods

Long exposures, dim light, and telephoto work require solid camera support. At a second or two of exposure time, mountain streams will look like flowing smoke. With a 20-minute exposure, stars will streak the night sky and the silhouettes of desert towers will appear out of the black. A slow shutter allows you to stop down your lens aperture, which increases depth of field—an essential technique for landscape work if you want sharp rendering of both wildflowers in the foreground and mountains in the distance. Even at fast shutter speeds, it's tough to hand-hold any lens longer than 200mm without blurring at least some of your shots.

I have three tripods. One stands head height, has a heavy-duty ball head, and seldom travels very far from my car. I get much more mileage out of a cheap and super-light backpacking model that I'm embarrassed

to use around my professional photographer friends. Sometimes I sta-
bilize this pod by hanging a bag of rocks from the center post. My third
tripod is a $10 fold-up thing with 4-inch plastic legs; it weighs an ounce
and has a Velcro strap that can attach to a ski pole or tree branch. It'll
hold an SLR, barely, but it's best with a pocket camera for summit self-
portraits and such.

Tripods are cumbersome, and many excellent adventure pho-
tographs have been taken by cameras propped up with rocks and
sticks. If you're going without a tripod, Galen Rowell suggests carrying
a small beanbag to cradle and level the camera and lens. Alternatively,
just bring a Ziploc bag that you can fill with dirt or sand.

A few tripod accessories are helpful. You'll need a cable release with
a lock knob for long exposures. If you're a solo boulderer and have an
electronic camera, a remote timer is handy. You can set up the camera on
the tripod, climb into just the right position on your new boulder prob-
lem, hit the remote button, and two seconds later the camera will fire.

Office Supplies

Two essential items to have at home are a light box and a good loupe.
You can't evaluate your work by holding slides up to a desk lamp or
projecting them on your wall. You can get a passable light box large
enough to view one twenty-frame slide sheet from most camera supply
sources for about $40. A loupe (German for "magnifying glass") is a
hand-held lens used for inspecting slides or negatives. A cheap loupe
may fool you into thinking that fuzzy slides are sharp. Don't let some
photo editor break the news to you. One excellent loupe is the Schnei-
der 4X, costing about $120.

A few more helpful items are a camel-hair brush and compressed-
air blower for cleaning slides and camera gear, as well as a film-safe sol-
vent for the nasty spills or stains you find on your slides when they
come back from a careless client or after a late-night editing session
fueled by too much strong coffee.

Bags

A sturdy camera bag or case makes the difference between gear that's
accessible and in working order and gear that's buried or broken. You
may spend years looking for—or trying to make—the perfect camera
bag. I have a closet full of camera bags and cases, some heroic and bat-
tle scarred, others unscathed and useless.

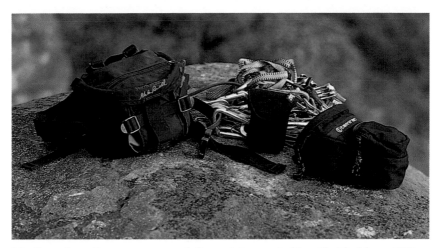

My three favorite camera cases: *left* a waist-mounted bag that holds an SLR camera body and up to four lenses, for on-rappel shooting, backpacking, and ski touring; *center* a neoprene pocket camera case for carrying on lead or on mountain runs; *right* a one-camera, one-lens kit bag for stuffing in a pack or haul bag when photography is secondary to going light.

Good pocket camera pouches are easy to find. I have one made of neoprene, which pads the camera well and keeps it fairly dry.

Your SLR gear calls for a few different cases. The neoprene cases made by Zing, which you can quickly fold open or closed without taking the camera out, are great for mountaineering and other times when you want your camera accessible in an instant. These aren't dustproof enough for general use, though. You should have another small case, Cordura with a zip closure, that will just barely hold your bare-bones, one-lens kit plus some film and filters. Get one that fits your camera's contours and minimizes dead space. For high-angle rock climbing, you can clip this case to your harness, strap it over your chest with its own harness, or carry it in your pack or haul bag.

You'll also need another bag large enough to fit everything you plan to carry while shooting from a rappel rope. It must ride well even when worn over a harness and when your body is crunched, tipped, or contorted. It should resist rain and blowing dust—padding helps here, and zipper closures—and hold its contents securely, even when it's open.

Fanny-pack bags are the most popular. Wear the pack in back as you rappel down into position, then swing it around front to shoot. Sometimes you can rest your elbows on it for a more stable shot. Bag

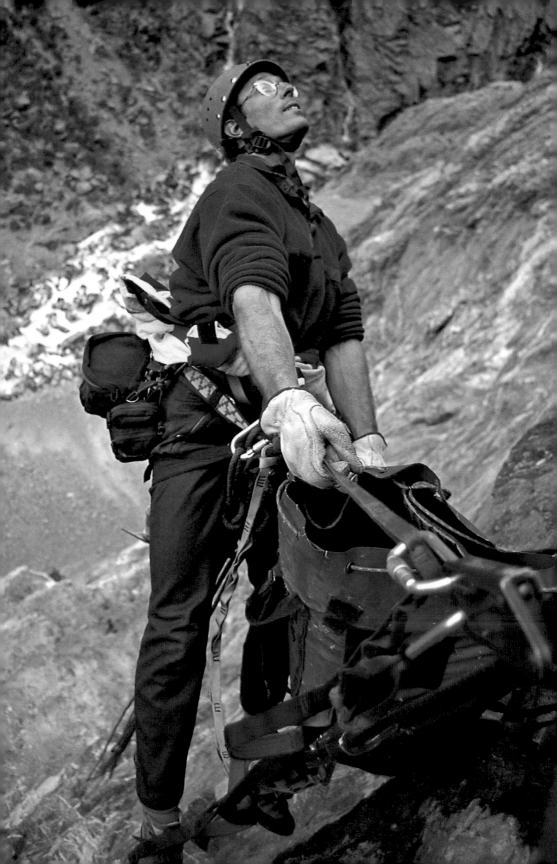

A waist-mounted, forward-opening bag for vertical shoots when you want to bring a large kit.

size should match your camera system. Mine can carry two camera bodies and about five small or three large lenses, plus extra film, batteries, candy bars, and so forth. A bag with flaps that open away from your body keeps your gear more secure in the common tipped-forward shooting position. I always back up the buckle closure by clipping the bag into my harness.

Some photographers prefer a shoulder bag for shooting on rappel. These hang more freely than a waist-mounted kit, so they're easier to access than fanny packs and less likely to spill. Unlike a fanny pack, however, they aren't good for hiking and scrambling.

You may want a third, narrower, midsized bag for hiking or skiing, one that can hold a few extra lenses but doesn't interfere with your arms when you carry it in front. You can stabilize a waist-mounted bag and get some of its weight onto your shoulder straps by running the neck loop over the sternum strap of your pack.

Opposite: **My midweight kit—a manual SRL and two lenses—hip-mounted, in the Black Canyon of the Gunnison, Colorado.** Mark Synnott

CHAPTER 4

CLIMBING ACCESSORIES FOR PHOTOGRAPHERS

Vertical shoots require you to carry not just camera equipment but technical climbing and survival gear as well. The bigger the climb, the more gear needed to rig it. See chapter 9 for specifics on climbing gear, most of which you probably already own. A few specialty items are listed here.

BOSUN'S CHAIR

If you're a big-wall climber, you may already own a bosun's chair for comfort at extended hanging belays. Hanging in even the most comfortable climbing harness for an hour is guaranteed to put your legs to sleep, and an all-day session can make you swear never to go on another shoot. With a chair, you can perch in comfort.

Drill holes for 7mm rope in each corner of a 9×15-inch scrap of half-inch plywood. Glue and/or duct-tape a piece of closed-cell foam over the seat, wrapping it around the edges where your legs will bend over. Sling the seat with two pieces of cord. That's it. Clip the slings to a jumar or other anchor when you're ready to sit.

STILTS AND BOOMS

When you're hanging on a rock face, shooting down on an approaching climber, you see lots of air and the ground below, but not much of the climbing terrain. Your view is parallel to the wall, so your shots are two-dimensional and that beautiful finger crack is obscured by the climber's body. If only you could walk out into space a meter or two. Well, you can.

 Stilts strapped to your legs are your lightest, most portable gadget for achieving an out-from-the-wall perspective. There's not much to designing a stilts system. Pick a material—2×2 wood or light metal tubing will work. Choose the length you want, attach foot platforms and two beefy straps with buckles or Velcro closures to each stilt, and you're set.

 Be warned, however: Getting into and balancing on stilts while hanging from a rope is not easy or without risk. Especially on less-than-vertical rock, you'll find it hard to get from hanging straight down on the rope to being pressed out from the wall on your stilts. Then, if one stilt slips or you tip too far sideways while shooting . . .

 A heavier but much more stable rig is a free-hanging **boom.** Basically, a boom is a collapsible metal triangle fitted with slings so that it can hang from a fixed rope. Booms are cumbersome. Most photographers who own one used it avidly right after they first made it, then let it gather cobwebs in the storage room (next to their heavy, expensive tripods). Only the true hardcore climbing photographer like Greg Epperson, who pioneered the out-from-the-wall perspective, can and will carry a boom to the top of El Capitan and rappel 1,000 feet with it.

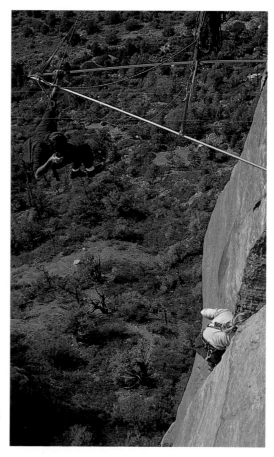

A boom is a useful but cumbersome tool for the serious vertical photographer. Here, John Burcham employs his $30 homemade boom in Sedona, Arizona.

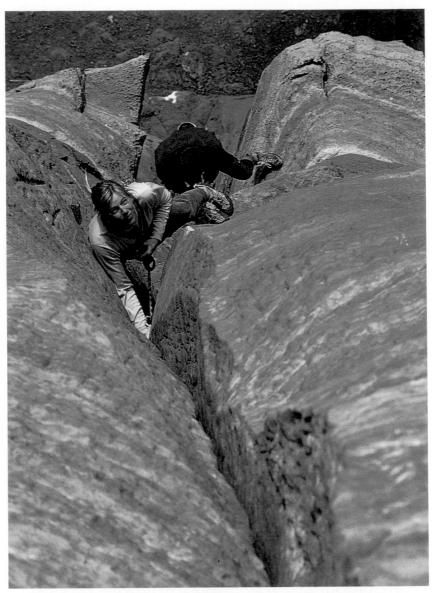

Above and opposite: While John Burcham and I jockey for position above her, Susan Ward leads up Dr. Rubo's Wild Ride on a redrock pinnacle above Sedona. In my shot (above), taken from an ordinary rappel position, you can't see much of the rock around Susan, and she is cluttered by the belayer in the background. In John's much better shot (facing page) taken from the boom, Susan is separated from her belayer, and you can see a nice sweep of the wall.

JOHN BURCHAM

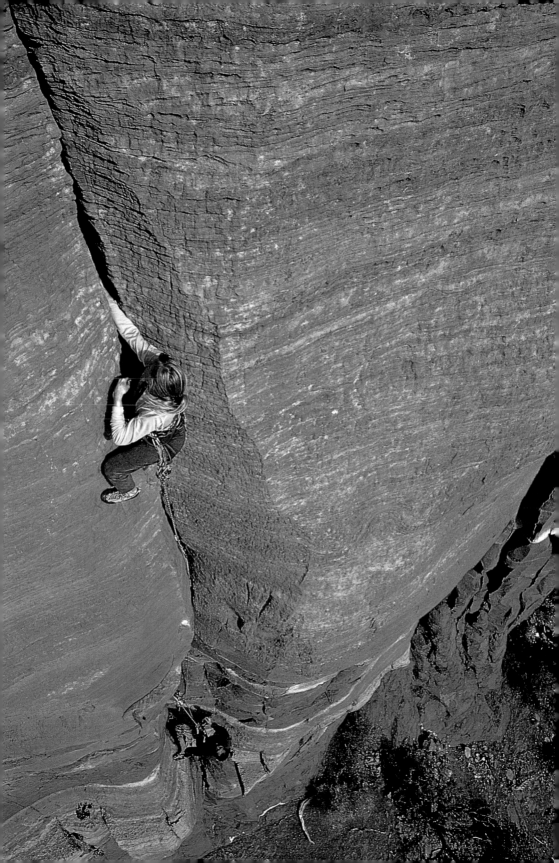

You can't buy ready-made booms, and there are as many designs as there are photographers. One simple design is described here. You need:

- Three 10-foot lengths of galvanized conduit tubing about $1^1/2$ inches in diameter
- Three sturdy bolts twice as long as the tubing diameter
- Matching washers and wing nuts
- About 50 feet of 8mm rope
- Four short loops of 1-inch webbing

Before you buy, lay out a length of tubing on the floor of the hardware store and give it a seat-of-the-pants test for bend resistance. If it seems flimsy, buy a heavier stock. Your most likely design mistake is to tell yourself that you won't actually walk on your boom, but just lean out from the end of it. Then, the first time out you realize that you need to scramble all over the thing, and five minutes into your setup you pretzel the too-light tubing. If you absolutely must minimize weight, go for more expensive portaledge-grade tubing, aluminum or steel, and make a more elaborate suspension system for each leg.

Once you've chosen your tubing, pound one end of each tube flat and drill a hole in each flattened place. Put two tubes together loosely with a bolt and wing nut. These are the legs of the boom.

Drill a bolt hole about $2^1/2$ feet from the free end of each leg. Attach the flattened end of the third tube (your cross tube) to one leg with a bolt, and lay it symmetrically across the splayed legs. Decide where you want to cut the cross tube: A short cross tube gives you a more acute leg angle, maximizing your extension from the rock but also making the boom tippy. A longer cross tube gives you more stability. A 50- to 60-degree angle at the apex is about right. Pick your angle, cut off the tube, flatten and drill the end, and complete the tripod with the third bolt. Your metal work is done.

To make the suspension, girth-hitch two short loops of webbing around the tripod apex, one on each leg. Do the same on each leg near the cross-tube attachment. You can duct-tape these loops in place and fit them with carabiners or steel screw links.

The boom will hang from these loops on lengths of rope. The rope from the two cross-tube supports should meet in a knot about 6 feet up from the tubes. The rope from the apex supports should be about 8 feet long and end in a knot. That's it.

The boom attaches to your fixed line with two ascenders—one for the legs, and one for the apex. By sliding the ascenders, you can adjust

the space between these two support points and level the boom for any angle of rock. It's best to leave extra rope on your suspension when you first construct the boom, then cut it off after you've had a chance to field-test the lengths.

As I said before, booms are cumbersome. To sample the out-from-the-wall perspective before you commit to making a boom, try shooting from a portaledge set up endwise. To get the boom perspective without the boom, try positioning yourself ate a natural promontory on the cliff—the lip of an overhang or an arete. Another trick for vertical or slightly overhanging rock is to bounce out from the wall, snapping your photo at the apex of your swing.

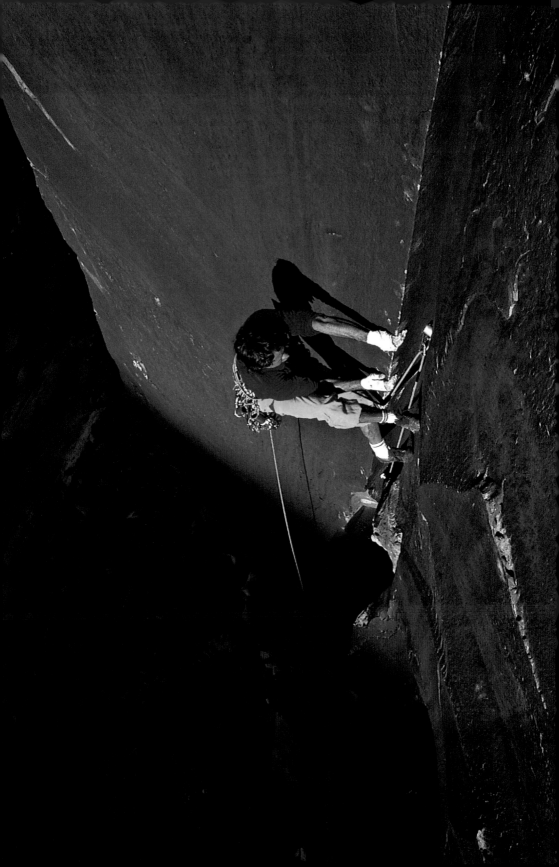

BASICS

Some who get into climbing photography are trained photographers. Most, however, are climbers who want to take something back from the wild places. For this group, the next few chapters should be particularly helpful.

If you want a thorough primer in the basic principles of photography, consult a more general text. Here, the uninitiated will find a brief treatment of the basics, and the more experienced will find comments on light, exposure, and composition particular to climbing photography.

Deep cracks can be as challenging to photograph as they are to climb. Here, Topher Donahue has an intimate moment on North Six Shooter Peak, Canyonlands National Park, Utah.

Opposite: Craig Luebben on the Sorcerer, near Moab, Utah.

CHAPTER 5

LIGHT AND EXPOSURE

LIGHT

The most important component of any photograph is the light that makes it. Midday light is typically "hot" (white) and "flat" (lacking in contrast), even on brilliant sunny days. In morning and evening, sunlight is "warmer" (yellow to orange), and objects seem to glow. Shadows are longer and more striking during these hours when the sun is near the horizon. The warmer light gives skin a healthy, appealing glow and can turn bland rock faces into tapestries of shadow and color.

Early and late in the day are the times to be out shooting. Many pros—especially those who shoot for the cliché tastes of the "stock" market—simply put away their cameras from nine in the morning until four in the afternoon. If you're that extreme, your slide presentations will look more like an *Arizona Highways* calendar than an adventure show, but you can expect to get some of your best images in those morning and evening hours. It's always helpful to scout the orientation of your climb and find out when it gets the best late or early light. During these reconnaissance outings, you can even take photos, sans climbers, from some of the ground positions you want to try out. Such dry-run images can help you refine a concept and identify the most promising elements, such as tree shadows or patterns in the rock.

It's harder to get interesting photographs with drab, flat, or low light, but it's a mistake to insist on a flaming sunset or drop-dead alpenglow. Subtle and curious lighting can give you even better pictures, if

Opposite: **In the late afternoon, harsh midday light begins to warm and soften and you can get pleasing but convincing shots like this one of Monika Chace on Utah's Monster Tower.**

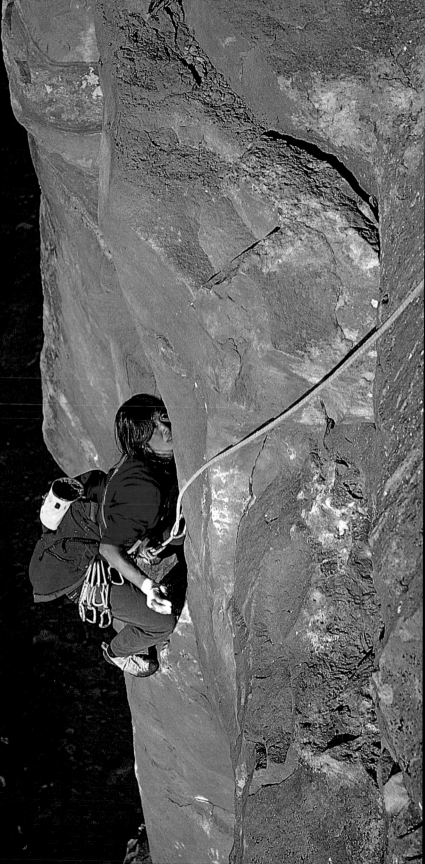

only because it's unusual and viewers' eyes are surprised. A climber spotlighted by a shaft of sunlight in the deep green shade of a southeastern forest is a much rarer image than another tequila sunrise crack climber on Utah sandstone. In those flat midday hours, seek out more subtle light shows.

Mountain light has some special characteristics you should know about. The earliest sun hits mountaintops. You don't need special know-how to take advantage of that, just a good alarm clock. There's a special quality to sunrise mountaineering photos. A beautiful yellow light bathes the climbers as if rewarding them for the hours of predawn effort they put in as the world still slept.

At last light, shadows are dramatic and the golden light spectacular. Realism is not the impression here in Joshua Tree National Monument; the rock seems to glow.

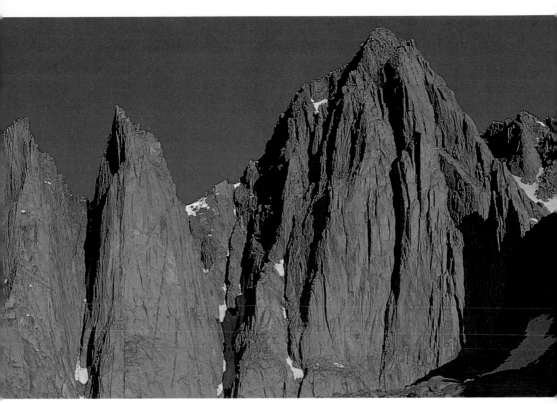

Alpinists know and love the day's first light, as here on the east face of Mount Whitney, California.

Mountains also catch the last of the sun's rays, when the sun is very low and the valleys have long been in shadow. This alpenglow is caused by the same phenomenon that makes the daytime sky blue— the scattering of the blue wavelengths of sunlight. The longer, redder wavelengths pass through the atmosphere untroubled, but the blue component of sunlight is deflected by molecules and particles and bounces around in all directions, including down toward you. Hence when the sun is out you see a blue sky, while at night, when the sun's rays are absent, the sky is transparent and you can see through it to the moon and stars.

When the sun is low in the sky, its rays pass through extra miles of atmosphere, losing blue light and becoming orange. You can usually detect this quality starting in late afternoon. When the sun is so low that

it hits only the protruding mountaintops, its light travels an extra-long distance through the atmosphere, and its red rays produce alpenglow.

Mountaineering, as opposed to rock climbing, is a great activity for photographers because it gets you out early for the spectacular sunrises and keeps you out late in the alpenglow. If you can only manage the burden of camera gear, you're not just admiring this light from afar, you're in it, perched on airy ridges or steep faces high above the shadowed valley.

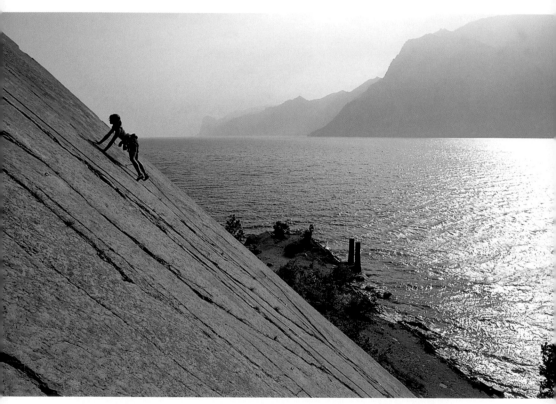

In this afternoon shot, the light on the Lago di Garda in Italy was still a bit harsh, but the reflection off the water made the shot unusual enough to be interesting.

Opposite: The dense forest of southeastern Tennessee filtered the midday sun, bathing John Bass in a strange green light and providing a woodsy background of mottled light and shadow.

The crag climber, however, is likely to find himself sleeping in and quitting early. The crag *photographer* who does this will end up with poor images. It's easy to put in a good day of climbing yourself, then pull out the camera and cajole your friends into shredding the last of their skin climbing in the rich evening light as you relax behind your tripod or dangle lightly from a rope. Thus, the climbing magazines are full of photos in nice evening light. Not surprisingly, the least exploited light in crag photography is early morning.

Mountain light has some invisible components to beware of. Just like your skin, film needs some protection against UV light. UV light lies just beyond the violet end of the visible spectrum. Most of this light won't penetrate the glass of your lens, but some can, and many color films register UV as a vague blue haze.

You can correct the blues of UV and skylight with filters. Skylight or haze filters are the most subtle of these warming filters, good for UV light and cloudy days. As mentioned in chapter 3, shaded snow and glaciers reflect the blue of the sky, appearing bluish themselves and tinting nearby subjects, and an 81A filter is about right for warming shady snow back to neutral gray.

Don't be afraid to experiment. The blue cast will make your scene feel colder and more harsh, perhaps just the effect you want. The visual cortex of the brain adjusts your perception of light, neutralizing the overall hue, and in general, your use of filters should be like that—subtle and naturalizing. Some photographers just say no to filters. One example is Kevin Powell, a California climbing photographer whose work is distinguished by deep blacks, rich colors, and striking graphics in sun and shadow; he calls his business Existing Light.

EXPOSURE

Unlike your eye, film is very specific about the amount of light it needs. Too much light, and the film will be bleached white. Too little, and it goes black. Your eye can easily see details in both the shadows and the highlights of a scene, but film—especially slide film—can't give a good rendering of both. Thus, getting the exposure you want in a photograph involves not just measuring the overall brightness of the scene but also picking which elements you want correctly exposed. You often have to let shadowed areas go black, or "blow out" your highlights.

You have two basic exposure controls: shutter speed and aperture. Shutter speed is expressed in fractions of a second (sometimes full

seconds) and determines how long light will strike the film. Aperture is expressed in f-stops and determines how wide the lens is open during that time. When you "open up" one f-stop, you double the amount of light hitting the film, the same as when you go one notch down in shutter speed. For example, f/8 at 1/500 of a second gives the same exposure as f/16 at 1/250 of a second.

The first step in choosing your exposure is to measure the light in the scene. Even the most basic modern camera has a built-in through-the-lens light meter that tells you when you've picked a combination of shutter speed and lens aperture that will correctly expose the film.

Autoexposure

Many electronic cameras have sophisticated matrix metering systems that guess your basic subject (sometimes using the distance reading from the autofocus system), take into account the brights and darks, and then pick the exposure using a computer program. In aperture-priority mode, you set the lens aperture, and the camera automatically sets the shutter speed. Shutter-priority mode is the opposite. Various program modes set both aperture and shutter speed automatically.

It amazes me just how well modern autoexposure systems work. That said, the auto setting should be just one of the tools you use for exposing your shot. Automatic metering

Cloudy days can be best for shooting climbs with overhangs, where direct sun would give a too-contrasty combination of strong light and deep shadow. Nancy Leas is climbing.

is invaluable for fast action in rapidly changing light, but matrix systems are designed and calibrated to give you "normal" photographs in a variety of lighting situations. If you always let your camera do the thinking, all your exposures will look normal—which sometimes means boring and seldom means unusual. Unusual may be just what you want.

Manual Metering

Even if your camera has a state-of-the-art metering and program system, there are many effects you can get only in manual mode. By selecting the exposure yourself, for example, you can turn a shadowed cliff line and climber jet black and silhouette them against building thunderclouds. Snow and ice also confuse autoexposure systems. Know how to get what you want, and don't rely on your camera to understand exposure better than you do. The only way to figure this out is to practice metering manually.

Manual metering involves taking simple measurements of the light in your scene, then choosing the exposure yourself. Among climbing photographers, I'm definitely something of a holdout (bordering on retro) in my equipment and metering style. Almost every photograph in this book was metered manually, so I'll make my case for it here, pass on my findings, and let you decide how much you want to use it.

Good manual metering takes practice. Get to know your camera and film. Burn through as many rolls of your favorite film as you can, experimenting. Ideally, your camera's light meter will have a spot mode, which measures only the light in a small spot in the center of the frame, but a center-weighted meter will work almost as well. Set the shutter speed so that you can adjust the aperture dial to cover all the "correct" exposures the camera meter suggests. Later, you can change the shutter speed and adjust the aperture proportionately.

To avoid letting color mess up your manual readings, imagine your scene in black and white. The camera's meter suggests exposures that will render the metered objects as 18 percent gray—approximately the average tone of lightly tanned Caucasian skin. If you meter off near-white Yosemite granite, however, the suggested exposure will be too dark, since the meter assumes the rock is an 18 percent gray. Conversely, if you meter off your friend's black T-shirt, the suggested exposure will give you an overexposed shot, with the T-shirt rendered a washed-out, 18 percent gray.

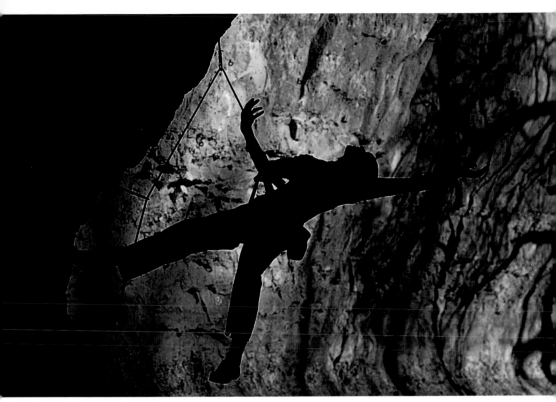

This sport climber in Jack's Canyon, Arizona, wasn't making much progress, but I loved the shadows on the wall behind him. To get the exposure, I spot-metered off the sunlit rock.

A good manual metering trick is to point your lens at something whose tonal value approximates a photographer's "gray card," a neutral metering card you hold in the same light that's falling on your subject. In summer, I can use the suntanned back of my hand as a gray card. For a backlit subject, I meter off my shaded hand; for a subject in direct light, I hold my hand in the sun and take the reading.

This trick is useful, but a photo has many objects in it, all differently lit. Shadows near a sunlit granite wall will be brighter than shadows not filled with reflected light. You need to pick an exposure that takes into account the range of brightness in your photo. Survey the lights and darks of the scene. Point the camera at the main subject and note the suggested aperture. Do the same for the brightest highlights and the

darkest shadows. Don't confuse the lighting of the scene with the different colors of the objects in it—meter readings from puffy white clouds or navy blue clothing will be skewed by their color. Look for near-neutral tones such as Caucasian skin or the blue of the sky.

Your spot meter readings may suggest exposures that differ by as much as four f-stops. Now you have to pick the effect you want. If you want rich colors in the highlights and don't mind black shadows, expose from your highlights reading. This means you'll stop down the aperture, or shoot at a faster shutter speed. Alternatively, if you're willing to "blow out" the highlights (let them go white) to keep good shadow detail, expose according to the meter readings you got from the shadows—that is, open up, or use a longer exposure. Split the difference and you'll get slightly bleached highlights, some shadow detail, and a neutrally exposed midrange. As a general rule, compose your shot to crop out any large black or white areas created by your exposure choice.

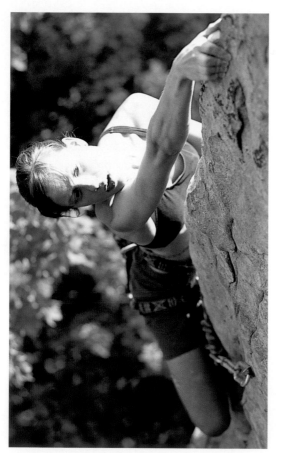

If you're not sure of the exposure, or even if you are, it's a good idea to "bracket"— take several shots at different exposures. Unless you're really confident, make this a normal procedure for important shots. If you're shooting slide film, expose at your best guess, then at one-third and two-thirds stop over, and one-third and two-thirds stop under. One of

Bend the rules sometimes. Standard practice in adventure photography is to expose for rich color in your highlights and let shadows go black. Here, I let the highlights blow out for a different look.

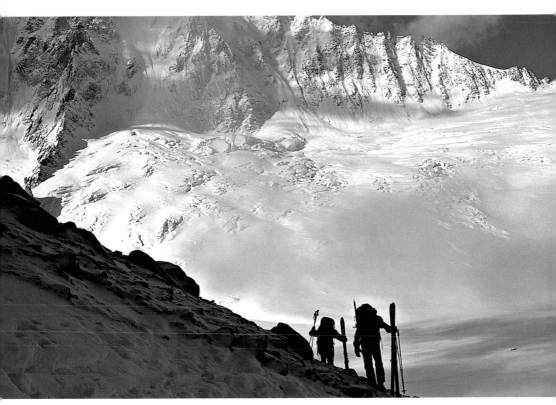

Automatic metering has a hard time nailing scenes like this, with extreme contrast and lots of clean white in the frame. A manual meter reading off a mostly clear sky suggested this exposure above the Argentiere Glacier near Chamonix, France. Notice the blue of the shadowed snow in the foreground, caused by skylight.

these five exposures will usually nail the effect you wanted. Bracketing is tough during fast action; an electronic camera with autobracketing is the ticket here.

Metering on snow-covered glaciers is tricky. Snow is white, and the alpine faces surrounding you are often dappled patterns of black and white, so it's difficult to get accurate meter readings. Your meter interprets the snow as gray and will generally suggest an exposure that's one and a half stops too dark. If your meter says f/11 at 1/250 of a second, open up to halfway between f/5.6 and f/8. The "back-of-the-hand" metering trick works well on snow. Meter off your hand, either sunlit or shaded, and your readings will be correct even for faraway objects in

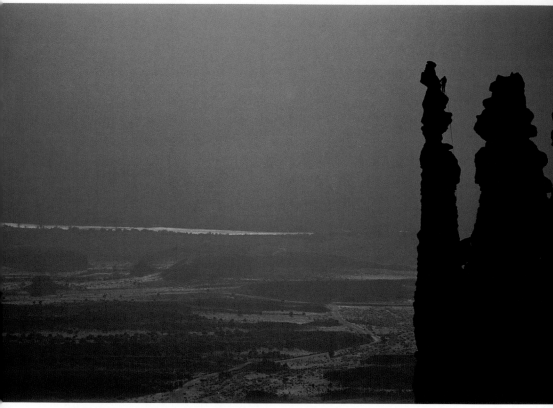

More unusual light—strong backlight and a hazy day. A telephoto lens helped keep the background somewhat abstract in this shot of the much-photographed Ancient Art Spire near Moab, Utah.

similar ambient light. Granite and light-colored limestone can likewise throw off your meter—one-half to one stop, since they're not quite as bright as snow.

Another tricky metering situation is backlighting. If a person is facing you with her back to the sun, her face will be shaded, but sunlight may be catching in her hair, and the background may be sunny and bright. In this case, automatic metering often exposes the shot for the background, and you'll lose all detail in your subject's face. Some electronic cameras have a special backlight mode. Otherwise, move in tight to take a manual reading off the subject's face, or use your shaded hand. Alternatively, you may want to keep the richness of the

background and let the subject vanish into the anonymity of a silhouette. Better yet, snap one of each and a few in between. It's hard to know what's going to look best in the final image.

The moon is a compelling but elusive photographic subject. In full daylight, it's seldom very dramatic, but nighttime moon photos suffer for lack of an interesting setting. Keep in mind that the moon is like any other sunlit object, and the correct exposure for detail on the moon's surface at midnight is the same as for an earth rock at noon. A spot meter reading through a telephoto lens will verify this, but most evening or night meter readings will badly overexpose the moon. If you do expose correctly for the moon, the landscape will be too dark. What can you do?

Here's one way to get around the problem. As for any low-light photo, you'll need a tripod. Set your meter to correctly expose the scene, ignoring the moon. Tape a piece of cardboard over part of the lens so it blocks the moon in the viewfinder. Expose the frame. Remove the cardboard and use the double-exposure mode on the camera to expose the frame again, this time at the much faster shutter speed needed to properly render the moon.

But how can you decide what that setting will be if you can't spot-meter the moon directly? Here's another exposure trick worth knowing. It's called the "sunny 16" rule, and it can also be useful if you have complete meter failure out in the wilds somewhere. For sunny objects, your correct exposure will be (very approximately) the reciprocal of your film's ISO rating at f/16. If you're shooting Kodachrome 64, for example, set your shutter speed to 1/60 (close enough to 1/64) and your aperture to f/16 for a sunny object. If your film is ISO 200, shoot at f/16, 1/200 of a second, and so on. With your shutter set to the reciprocal of your ISO, shaded objects will be correctly exposed at about f/4. Choose something in between for cloudy bright, light overcast, and the like. Obviously, this is guesswork. Experiment thoroughly if you plan to use this method for more than a seat-of-the-pants estimate in emergencies.

CHAPTER 6

COMPOSITION

Composition is how you arrange the elements within a photograph—what you decide to include and leave out around the edges, where in the frame you place the main and secondary subjects, and what you do with the shapes and lines in the scene.

MOOD

The first step in composing a photograph is having some idea of what you're trying to express. "A climber on a steep wall" is vague. Sharpen the idea by considering the psychology you're trying to get across. Fear of what lies ahead? Aggressive determination? The joy and awe of a small being in vast nature?

Each mood suggests different compositions. For fear, you might place the climber low in the frame, wait for him to look up, and pick an exposure that renders the rock dark and foreboding. You want the subject large enough to show the intimidation on his face, but small enough to look overwhelmed by the situation.

For the aggressive determination photo, fill the frame with the climber. His facial expression and body language are important. Consider graphics, too, the lines and shapes in the photo. Horizontal lines are placid, and vertical lines are static. Including a strong diagonal line in the composition—for example, a forearm reaching across—will add energy and enhance the feeling of motion and action.

For the vast nature shot, move back or choose a wider lens to dwarf the climber. Bright-colored clothing or a dancelike pose helps express joy. Place the climber high in the frame to suggest him rising to the occasion, or place him low to put more emphasis on the power of the environment.

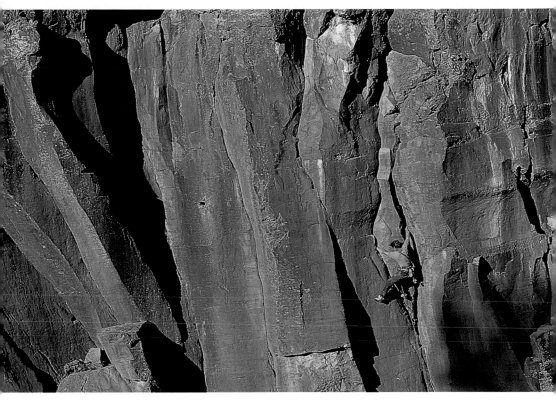

Basalt geometry in Paradise Forks, Arizona.

These are oversimplified examples. In fact, composition is more than a little subjective and intuitive, and other compositions might better suggest these same moods. If you can articulate your idea well enough to agree or disagree with these sample compositions, you've got the point. What's important is that you have a specific concept and make precise choices to achieve it. This holds true for your light and exposure decisions as well, but it's of particular significance in composition.

GENERAL RULES
- Avoid centering the subject. Photos with a climber dead center often have a snapshot feel, and the composition gives few clues as to how to interpret the scene. A better starting point is the "rule of thirds." Imagine your viewfinder crosshatched with a tic-tac-toe board of equally spaced lines, two running vertically

and two horizontally. This pattern forms four "sweet spots" where the lines cross. The areas around these four points are good places for the main subject.

- Avoid clutter and distracting elements, especially near the edges of the photo. Your foot sticking into the bottom of the frame, half of a bouldering spotter, five other in-focus climbers on a crowded sport-climbing wall—these things all weaken the photo, drawing the eye away from the subject like accidental inkblots on a drawing. Of course, inkblots can be intentional. You may purposely include your foot in an aider when you shoot your partner jumaring up a pitch on El Capitan to show your hanging belay. Break the rules as much as you like—just don't break them by accident.

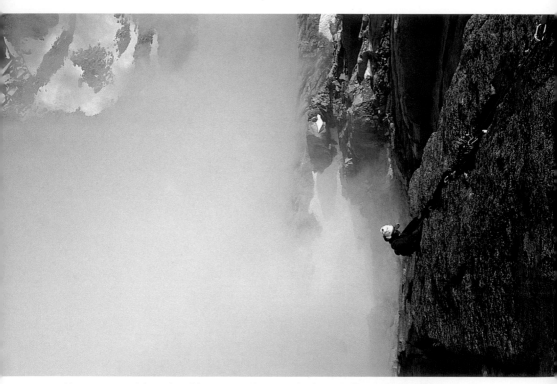

Your composition should support the mood of your photo. *Above:* The climber is small and his body language introspective, supporting the misty, dreamy vertigo of the scene. *Opposite:* A beginning climber gives his best on a hard climb. His face is large in the frame and tells the story, while the diagonal lines in the composition add energy.

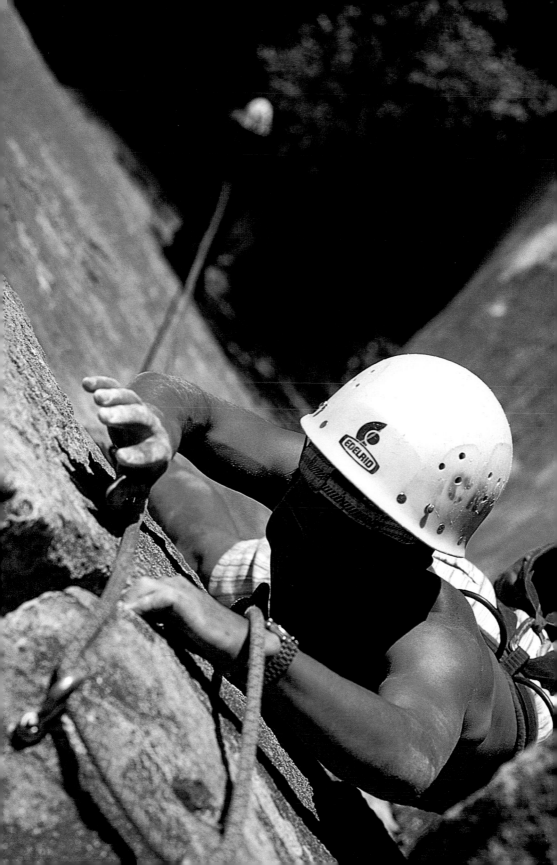

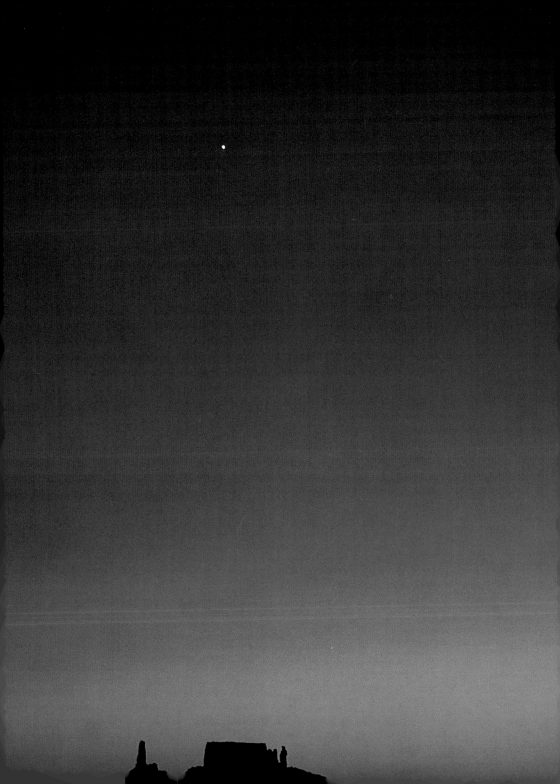

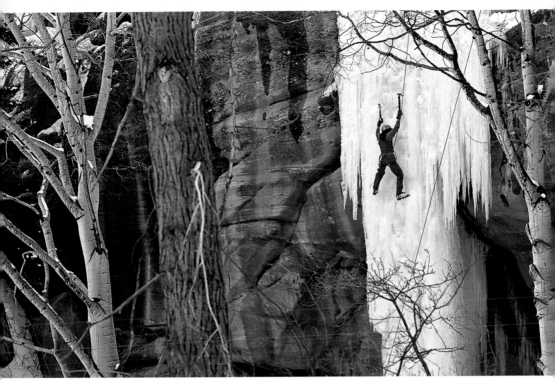

This photo of Beth Wald, accomplished climbing photographer, demonstrates the rule of thirds (as well as good ice technique). Centering your main subject gives the image a static quality, while placing her in one of the four "sweet spots" near the corners, as here, encourages the eye to explore the photo.

- Make lines lead somewhere. If there's a sharp shadow line leading diagonally across the frame, your eye will follow it. At the end of its journey, the eye wants to find something—a climber, a tree, anything. Lines that lead right out of the frame tend to draw your attention there—out of the photo and on to something else.
- Strive for visual balance. A climber, a boulder, a nearby tree, and a well-defined cloud all have visual "weight." This intuitive quality comes from both size and color—the darker, the heavier. Stacking "heavy" elements on one side of the photo will make it feel like it's about to tip over. Balance the climber and the cliff on the right with a

Opposite: **Lines should lead somewhere. Here a typical desert-tower sunset shot includes an added spark.**

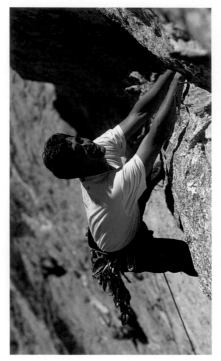 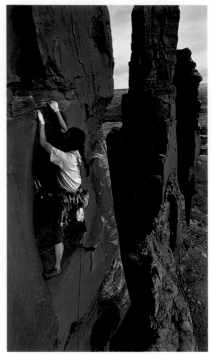

Use a longer lens or wider aperture to keep your depth of field shallow (left) to isolate subjects and soften busy or uninteresting backgrounds. For greater depth of field (right), stop down and use a wide lens.

cloud on the left. The most pleasing compositions avoid balance-beam symmetry and use a more natural scattering of objects of differing sizes. Unbalanced compositions can be striking and successful, but they're slightly disturbing. Learn to recognize them, and use them when you want to achieve a particular effect.

DEPTH OF FIELD

Depth of field is the range of focus in a photo. A shot with great depth of field may have sharp focus on everything from edelweiss in the near foreground to the Matterhorn a mile away. A shot with shallow depth

Opposite: "X marks the spot." Consulting the map at a hanging belay on Whitesides Mountain, North Carolina.

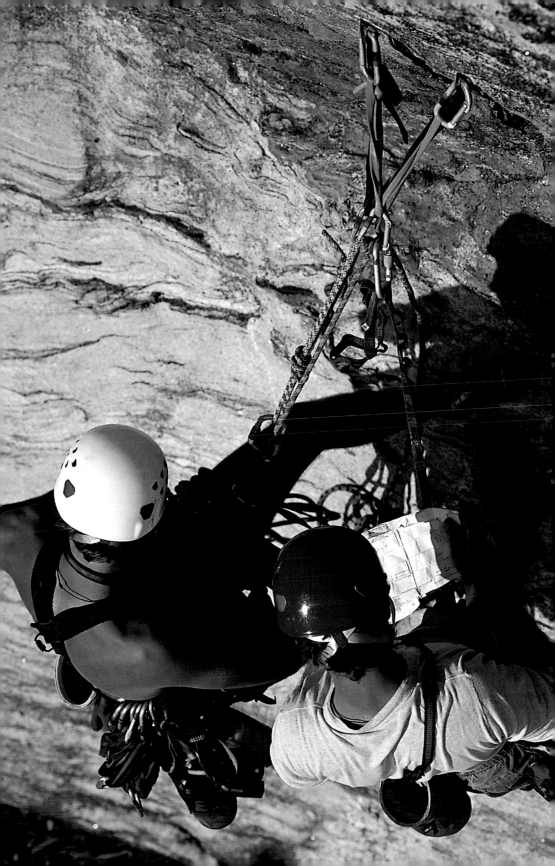

of field may be sharp only on elements between 10 and 12 feet from the camera lens—perhaps a climber's face. Depth of field is an important quality to know about and manipulate.

Shallow depth of field isolates subjects. If you're shooting a climber against a cluttered and busy background, throw everything but the subject out of focus or you'll get a snapshot-looking image of a climber lost among a lot of other things. Conversely, you might want to show a circus atmosphere with six hang-dogging climbers all in focus. For this effect, go for maximum depth of field. Or, choose an intermediate depth of field: sharp focus on the main subject, giving the shot a center of interest, then soft background focus that still lets you see the other climbers.

You have two main controls over depth of field: aperture and lens length. The larger the aperture (the lower the f-number), the shallower the depth of field. You see your minimum field depth when you look through the viewfinder. To give you the brightest image in the viewfinder, the camera opens the lens completely for focusing, stopping down when you snap the shutter. Most cameras have a depth-of-field preview button that stops down the lens to your chosen f-stop and shows you the depth of field. At narrow apertures, however, this preview makes the viewfinder so dark you'll have no clue what's in focus.

Many lenses have color-coded marks near the f-stop and distance numerals on the lens barrel for estimating depth of field. These are helpful for low-light or fast-moving situations when it's hard to focus by sight. If the f/8 numeral on the lens barrel is red, for example, find two red lines scribed nearby. As you move the focus ring, these red lines will "bracket" some of the distance numerals.

On a 20mm lens, for example, if one of the red f/8 lines is on infinity, the other line falls just under the 3-foot mark. Thus, at f/8, a 20mm lens will give a sharp rendition of everything in the frame farther than 3 feet away. In comparison, with a 200mm lens at f/8, if objects at infinity are in focus, the depth-of-field lines indicate that objects even 100 feet away will be out of focus. This is both a drawback and a strength of long lenses—even at narrow apertures, their depth of field is shallow, but this same quality makes them great for isolating subjects.

The worst depth-of-field problems arise when all parts of the subject—her face and her hand, for example—aren't equidistant from the camera. Avoid out-of-focus body parts by shooting with a wide-angle lens stopped down as far as light permits.

CHAPTER 7

SHOT TYPES

LANDSCAPES

That vague category of photograph called scenics or landscapes may be the hardest of all shots to pull off successfully. You don't have a face or a wild climbing move to draw interest, and you're likely to fall into the trap of "taking it all in." You can't. Your landscape photography will greatly improve if you emphasize some aspect of the landscape in each photo. For example, instead of just shooting a canyon scene, concentrate on showing the narrowness of a canyon and the steepness of its walls. Shoot with a long lens to compress distance and render the walls vertical. A wide-angle lens will make the canyon look deeper, but it will open up the space near your vantage point, pushing back the walls. Work the depth and airiness of the canyon in a different shot.

Include definite subjects or strong visual centers. A mountain horizon is much more compelling if it contains a dominant peak to catch the eye, and then sends the viewer on to survey the rest of the scene.

Take care of foregrounds. If you're shooting a rock face or mountain, choose a vantage point where you can compose an interesting foreground for the photo using boulders, trees, tents, or people. Try getting on top of a hill or a boulder, so that the foreground stretches out a bit. If your composition has a strong foreground subject, the landscape can form more of a backdrop and isn't forced to produce some object that can work as the center of attention.

Landscapes are best shot with a tripod, since you'll often want to shoot in the low, warm light of early morning or late evening, and stop down your lens to maximize depth of field. Fuzzy trees or flowers in the foreground can ruin an otherwise striking landscape shot. Stopping

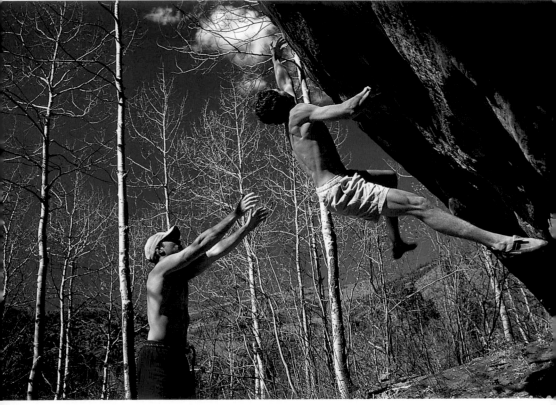

Freezing the action; Scott Leonard climbing in Redstone, Colorado.

down in low light means very slow shutter speeds, so hand-holding the camera is out.

CLOSE-UPS

Close-up perspectives are easy to overlook when you're surrounded by mountain grandeur. Notice the little things. Only a close-up can bring out the contrast in textures between ice and ice ax, granite and moss, hands and climbing gear.

Close-ups, perhaps even more than landscapes, demand good depth of field. You'll be very close to your subject, where depth of field is shallowest, so stop down that lens. Wide-angle lenses have better depth of field and are much easier to hand-hold at slow shutter speeds, so try them first. Shooting wildflowers with a wide lens,

I end up with more bad landscape shots than any other kind. Two ways to make things more interesting are unusual light (*top*) and political commentary.

Even fairly abstract landscape shots benefit from a subject or center of attention.

however, almost always spreads out the blossoms and diffuses the color, giving disappointing results. A longer lens on a tripod concentrates the color in the frame.

PORTRAITURE

Climbing is about people in the mountains, so you can't shoot climbing without some portraiture savvy. People are interested in people—it's an inescapable fact. Viewers' eyes go right to the person in a photograph, and if there's a flaw in your rendition, it's the first thing they'll notice.

"Don't shoot until you see the whites of their eyes" is good advice for climbing photographers. Nothing puts a bigger damper on a great sports-action photo than an expressionless head of hair facing the camera. If you're shooting from above, hold your fire until the climber looks up. No matter how great the foot-next-to-the-hand move looks, chances are, if you can't see his face (just a glimpse is enough), the shot will flop. If you're shooting from the side, you can catch a good profile or, better yet, a good expression when the climber looks toward you. If he's looking the other way, your shot will fall flat.

Opposite: **Close-ups avoid one of the common problems in climbing photography—too much going on. In a close-up, you pick one thing and focus.**

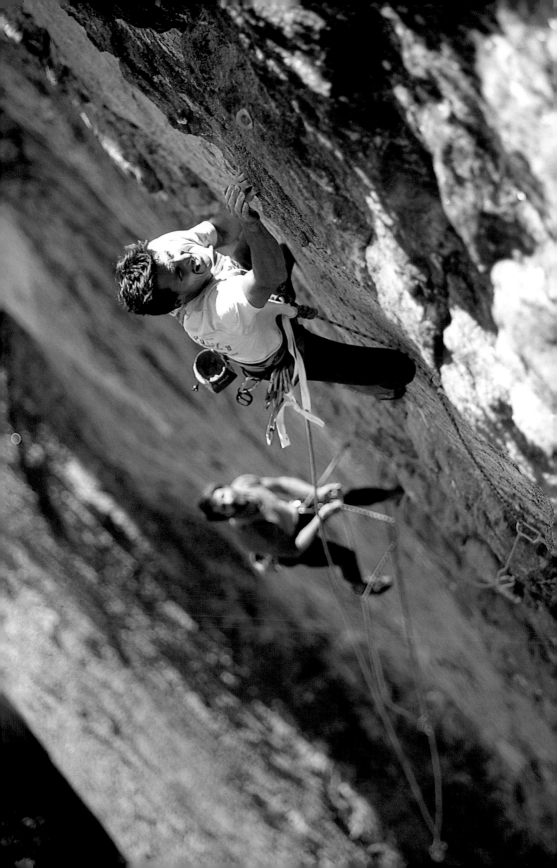

Your friends and models are handsome creatures, especially when they're concentrating on what they love best. Put some energy into adventure portraiture. Here, Steve Levin scans a route, high on a wall in Colorado.

Roped climbing involves teamwork—and sometimes the lack of it. This element will enter your photo whether you intend it to or not. The belayer can add or drain energy from a shot. If he's paying attention and looking up, the whole scene takes on more drama. If he's looking away and distracted, viewers of the photo will tend to do the same. (By the way, teamwork is a very marketable theme. As an editor, I got more calls from high-paying ad agencies looking for these kind of climbing shots than for any other.)

MOTION

Compared with skiing, mountain biking, and even hiking, climbing is static. It may take minutes, even hours, to make a few feet of progress. Still, there's motion, and it's important. Subject motion ruins many climbing shots. Only in a fall does a climber really go anywhere—the foot and hand movements are seldom dramatic. Showing that movement as blur usually adds as much to the photo as if the head or hand was merely out of focus.

Opposite: **The attentive belayer, Doc Bayne, is as important to this image as Arno Ilgner's facial expression. Belayers looking down drain energy from a photo.**

If you do include motion, your task is harder. If the subject is moving her foot, make sure she's looking down toward it, or the blur of the foot will merely be distracting in the photo. Blurred hands can add drama to a move, especially if the target hold is conspicuous and in focus and the climber is looking at it. Still, a shot with that sinewy hand in sharp focus, frozen in midreach, may be even better.

Truly gymnastic climbing—especially bouldering—has bursts of real movement that are well worth playing with. Use shutter speeds of 1/30 of a second or longer for real blur. If you hold the camera steady while the climber lunges upward, the rock wall will be sharp and the climber blurred, the reverse of what you really want. Pan up with the climber as he moves, and the wall will blur and, if you're lucky, the climber will stay sharp.

An electronic camera with a good flash and through-the-lens metering is the tool of choice for real motion imagery. A "rear curtain" flash mode is useful here. The flash fires only at the tail end of a long shutter opening, so the film records a good blur leading into a fill-flashed image of the subject frozen in motion, as if with a fast shutter. It's a great effect but is always a bit artificial looking, and it's easier to describe it than to do it well.

To get a natural look with artificial light, always set your flash below the suggested intensity. Better still, use some sort of "soft-box" to diffuse the edges of telltale shadows. The bigger the box, the more natural the effect, but you'll be limited in what kind of lighting apparatus you can drag around in the mountains. You can find inexpensive, featherweight diffusers, like little shower caps for your flash, that help quite a bit.

TO POSE OR NOT TO POSE?

Professional climbing photographers are all over the map on this question. Some set up, wait, and then create their photos from what happens naturally on the climb. This is a pure and rewarding way to shoot— when it works—but places extreme demands on your patience and reflexes. If you miss a shot, you can't say, "Would you do that move again?" Your models obviously will like this approach. Even if you've

Opposite: **Climbing may not have the rushing motion of downhill skiing, but those little moves can be thrilling. Here,** *Climbing* **magazine's photo editor Tyler Stableford pops a tool in Vail, Colorado.**

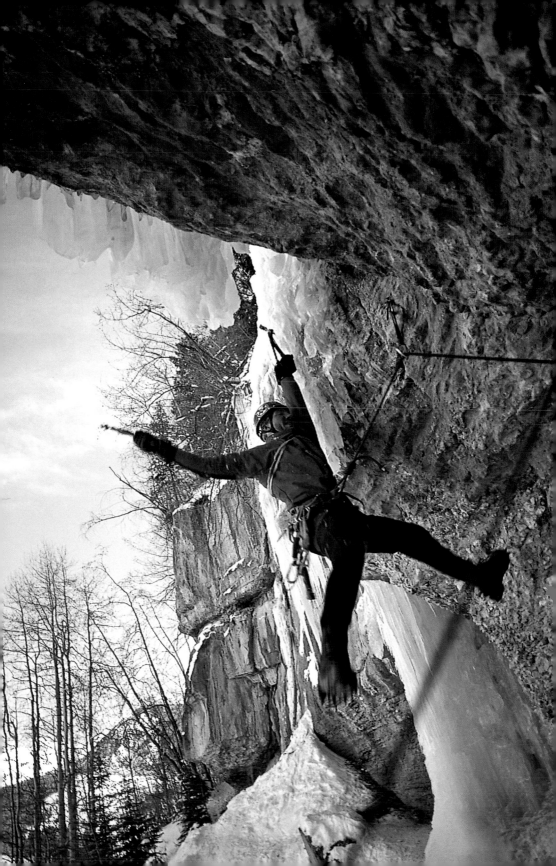

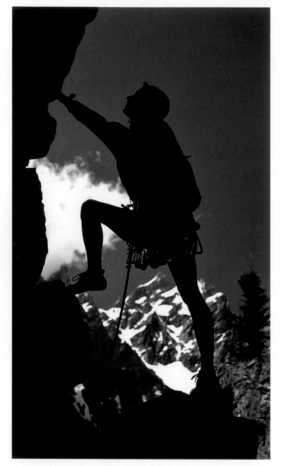

Sometimes you can't resist posing a shot. Julie Seyfurt humored me with this pose on Baxter's Pinnacle in the Tetons, Wyoming.

coaxed them into getting up at some ungodly hour to catch first light, once they're on the rock, they can just climb.

One touch that can really help is to carry some spare clothing in a variety of colors for your climbers. For distant shots, especially, a bright shirt can be just what you need to make a tiny climber stand out and work as a subject. If you're going someplace exotic, clothing companies will sometimes give you things, especially if you can convince them that there's a good chance the photos will end up in print. It never hurts to ask. Alternatively, check your local second-hand store for gaudy items.

A full pose-down will not guarantee good photos. Take perfect light, clothing, and camera position, then add direction—"Now reach up and left for that (imaginary) hold"—and you'll get lots of photos that look plastic and staged. There's an art to posing climbers. One master is the Austrian photographer Heinz Zak, who manages to achieve an authentic feel in "too-perfect" settings. Typically, he'll home in on one small, promising section of a climb, then have the climber repeat that section over and over, getting more and more exhausted—and expressive. If you work this way, you won't waste time and film on inferior sections of the climb and you'll get multiple chances to catch dynamic body positions and facial expressions. You'll also give your model a good workout.

People skills are a valuable asset for the climbing photographer. If you're friendly and comfortable with strangers, if you can put people at ease and make them laugh, you'll get much better results.

Although climbing photography doesn't exactly influence important world events, journalistic integrity still matters, especially for "news" shots. Be truthful in your presentation. It's dishonest to sell a photo as "so-and-so onsighting the first ascent of Supercrack" if in fact you got him to return the next afternoon when the light was better.

For "editorial" photography—such as the photo galleries of climbing magazines—it's not standard to pay your models. If you're doing advertisement work, however, they should receive some sort of day rate or free gear. If you want people to help you, you have to take care of them. Don't assume that seeing themselves in print is all the reward they need, unless you, too, are working for free. Send them prints or outtakes of the shoot, and if you score big on a photo, you owe them a six-pack at least.

Obtain model releases for commercial assignment work. I've never been asked to show a model release for a climbing photograph, but it's a good idea to have them on file.

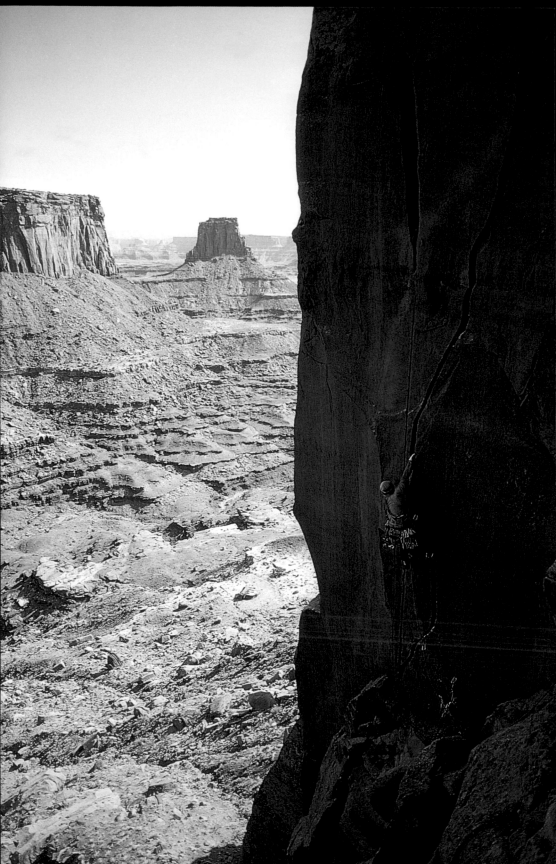

GOING VERTICAL

One of the things that makes climbing photographs appealing is the rugged scenery, the sweeping verticality of the backdrop. Of course, this means the photographer must get into these wild places. Sometimes, strolling a few meters from your car is all it takes. More often, you're hiking, scrambling, and tangled up in your own ropes and climbing gear.

Any sport photographer must manage exposure and composition with moving subjects, but you'll have to do this while set up in extreme terrain. You may need to outhike and outclimb your subjects, get up earlier, and climb faster while carrying more. Technical shoots—those requiring ropes—add a whole new dimension. You might rappel 200 meters down a cliff so overhanging that it requires trick rigging just to keep you from ending up way out in space, spinning helplessly, with no climbers in sight.

Opposite: **Steve Levin and Monika Chace on Monster Tower, Canyonlands National Park, Utah.**

CHAPTER 8

CAMERA CARE IN EXTREME ENVIRONMENTS

Climbers go places that cameras don't like. Given the choice, a camera would vacation in a warm, dry place where it didn't have to get up off its tripod, a place with no wind and no dust—preferably indoors. Contrast this ideal with a place where temperatures change dramatically, the air is full of blowing dust, camera bags get slammed around like lost luggage, and falls and collisions are real possibilities. This, of course, describes climbing.

Impact
You must protect your camera from the bumps and abrasions it will suffer on a rock wall. Immediately discard the leatherette case that came with your camera and get a good, padded bag as discussed in chapter 3. Extra lenses are best nestled between padded dividers within the bag, ready to grab; individual pouches are too hard to access. When putting a cased camera in a climbing haul bag with other gear, keep it wedged close to the center. If you pack it so that it rests against the outside of the bag, it will probably not look the same when you take it out.

Dust
Crags are often windy, and wind carries dust. If dust gets inside your camera, it will scratch the film and ruin delicate workings. Make sure that your camera bags seal. Zippers are best. Keep the camera zipped away when you're not shooting, and find a windbreak when you change film. Change film inside a nylon jacket if you can't get out of the wind. After a dusty shoot, wipe down the camera with a clean cloth and blow out all moving parts with an air gun.

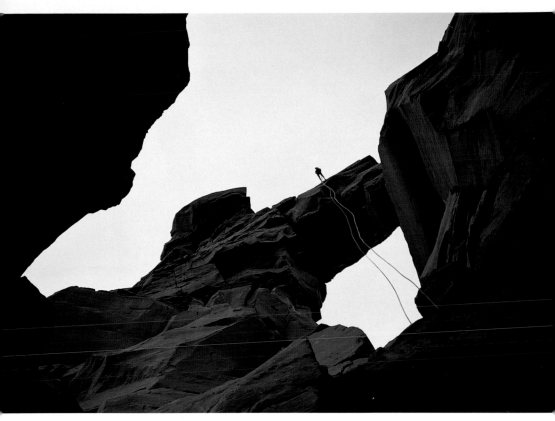

The great studio in the sky. An unusual view of Washer Woman Tower, Canyonlands National Park, Utah.

Water

Don't be afraid to get your camera damp—a little water usually won't hurt it. Foul-weather photos are rare and well worth gunning for. But don't push your luck. Take your shots and then stow the camera safely.

An umbrella is a useful wet-weather photography tool. You can shock-cord a small umbrella to your tripod or backpack, providing a dry haven for the camera and lens even in a driving rain. Alternatively, you can hide under trees or rock overhangs and still capture nature's fury a few feet away.

Sea-cliff environments are nasty for cameras. Salt air and spray cover your camera with a corrosive film. Do a full wipe-down with a damp cloth after a day at the beach. If you drop your camera in salt water, rinse it, immerse it completely in fresh water, and rush it to the

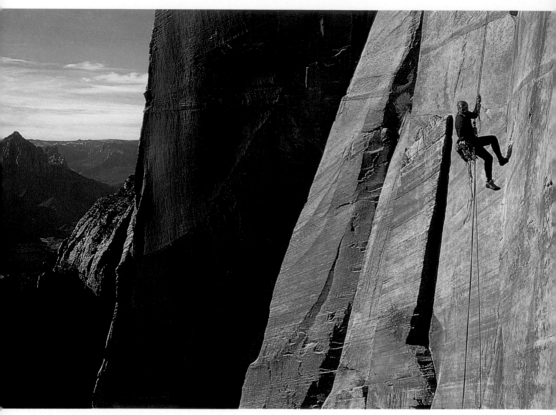

Big walls look clean and steep in photos, but climbing them is like working construction. Jammed-full haul bags and days of rope time will punish your camera gear.

camera emergency room. The "doctor" may be able to fix it up, but if you let it dry, oxygen will do its thing, and the camera will be history.

Cold

Winter and alpine environments are tricky. Cold batteries are weak and drain quickly. In serious cold, carry two sets of batteries (plus your spares, as always), warming one in your pocket while the other works. Switch them every hour or so. Chemical hand warmers in your pockets and camera bag can help warm your chilled equipment (and fingers). Of the various battery types, lithium are the best for severe cold.

Manual cameras are less cold susceptible, since the winder, exposure controls, and shutter release all work mechanically. The light

Condensation can kill your camera in winter. Know how to protect it.

meter, however, runs on batteries, and without this you're severely handicapped. It pays to be familiar with your favorite film and the exposure settings you use in various types of light, so you can make educated guesses if your camera batteries die unexpectedly.

Cold air holds little moisture, and with this dryness comes static electricity. In cold weather, rewind film slowly, or you'll create a little fireworks display inside your camera that will show up on your film.

Bringing a cold camera into a warm hut or tent can cause big problems. You've just caught the last light on the Matterhorn, and you bring your camera into the warm, humid environs of the Shoenbiel Hut. Moisture condenses instantly on the cold metal, including the wee crevices between moving parts. You wipe it off as best you can, but when you take the camera back out the next morning, this moisture freezes solid, ending your photography for the day.

To prevent condensation, put your camera and lenses inside large Ziploc bags before you come in from the cold. Squeeze out as much air as possible, seal the bags, bring the gear inside, and let it warm up in its microenvironment of dry outside air. Once the camera is at room temperature, condensation is no problem. Bringing a warm camera out into the cold is also no problem.

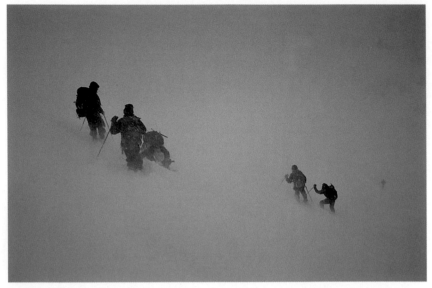

Full conditions in the Alps. While you suffer, try to remember to snap a few shots.

When camping out in winter or on high, cold climbs, remove your camera batteries, slip them in a ditty bag (along with your toothpaste, lip balm, and anything else you want to keep unfrozen), and keep them in your sleeping bag.

Modern camera lubricants work in the coldest weather, so "winterizing" shouldn't be necessary. If you have an older camera, however, or plan to visit the polar regions and want to be on the safe side, a good camera shop can winterize your camera with freezeproof lubricant for about $50 (have it cleaned it at the same time).

International Travel

Avoid displaying specialized photo bags when traveling. Name tags like Tamrac and LowePro are thief magnets. It's better to hide your gear inside normal luggage—the more ragged, the better.

Carry on all your film. It gets X-rayed, but the dose used should be safe for all but super-high-speed film. If you're really worried, insist on having your film hand-checked, although customs may well open each and every canister. You won't avoid X rays by packing film in your checked luggage. Checked bags get zapped ruthlessly, at much higher doses than hand luggage, putting film in peril.

CHAPTER 9

RIGGING

Taking photographs on vertical walls is dangerous. You're exposed to the same hazards as if you were climbing, but your attention is on photography—prime conditions for an accident. Don't rush, no matter what the light is doing. Get started in plenty of time, and have your system dialed.

Make safety your first priority. You can knock rocks down on the climbing team with alarming ease. Even a pebble can kill. Protecting your climbers is the most important part of rigging. If possible, do all the rigging before anyone is below you.

The best way to try out different shot types and learn the joys of rigging is to do a full-scale photo shoot on the familiar terrain of your local crag. There, you know all the anchors and will have a few favorite climbs you'd like to shoot. Conceive the photographs beforehand. What parts of which routes will you shoot? What camera angles and lenses will you use? Make a short list of shots—say, six shots on three different routes. Look over the following sections and go to it.

Keep in mind that on multipitch climbs, you can be on the cliff face yet avoid special photographic rigging simply by teaming up for tandem climbs. Two parties climbing the same or parallel routes will have spectacular views of each other. You can use this style of shoot with good results anywhere from the Gunks to El Cap to the Alps. A variation—more demanding of your climbing skills and speed—is to rope-solo next to the party you want to shoot. This works best if you get started first and your subject's route is hard and yours easy. Otherwise, you'll find yourself behind instead of slightly ahead, where your shots will be best.

Once you've undergone the stress and hassle of cliff rigging, you'll appreciate the many good camera positions on the ground. Ground locations are good for telephoto and low-light work because you can use a tripod. Don't overlook cliff-top vantages you can reach simply by hiking. Remember, looking through a camera lens at the edge of a cliff is not safe. My standard cliff-top pack includes a 50-foot length of 9mm rope for anchoring in and leaning out. That said, realize that you'll get some of your best images when you're hanging on a rope in the middle of some cliff, far from the comforts of level ground.

SPORT CLIMBS AND RIGGING FROM BELOW

When shooting sport climbing, you usually rig from the ground up, climbing the route you want to shoot or one nearby. Sport climbs often end far below the tops of cliffs, so they may be difficult to reach from above. Ground-up rigging is safer and easier than rappelling off the top of a cliff, since you can see your destination, and rockfall is less likely.

You don't need much special gear to shoot sport climbing. Although static line is better for big projects, regular climbing rope is more versatile for sport shoots. You can even get by without jumars if you have a helper, know exactly where you want to set up, and don't descend too far. When shooting sport climbing, I almost always rappel on a Gri-gri, since I don't need to descend far and it's easy to lock off and shoot. A chest harness will help you keep your shots steady when leaning back on the rope and prevent a long shoot from turning into an ab workout.

To begin a sport shoot, climb the route you want to photograph, if you can. This is the quickest way to rig and will give you an idea of how to shoot the climb—where to expect falls, where the best moves are. If the route is too hard for you, don't be intimidated. Even the most extreme sport climbs are easily ascended with a little trickery.

Wear your rock shoes and rack up with plenty of draws, one aider, and a telescoping cheater stick. Free-climb when you can, rest at convenient bolts, and use the stick for clipping above and yarding past hard moves. Using this method, any competent climber can quickly reach the anchors of the hardest sport route, then set up for the shoot. You can do this routine with a self-belay, using either a stout tree or the first two bolts of the route as an anchor.

On one-pitch rigs, I've found that it saves time and energy to establish the rope first, carrying no camera gear for the strenuous shenanigans. Once at the anchors, I can either pull the rope through and haul

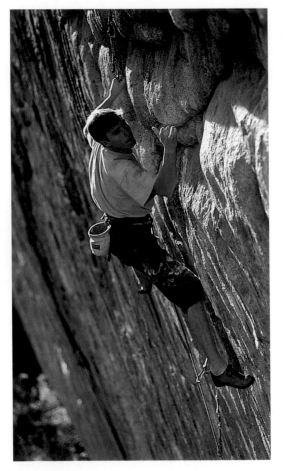

Sport climbs are the easiest to rig, which might explain why you see so many more sport-climbing photos than any other kind. Here, Dave Pegg works a project near Aspen.

the camera gear up, or descend, remove the quickdraws (or not), and jumar back up into position with my camera gear. I might clip my line into a few helpful bolts—perhaps even on another route—to keep the rope close to the rock and running where I want it.

Sport climbs tend to be clustered, so don't overlook an adjacent route that might make a better vantage point.

MULTIPITCH CLIMBS AND CLIFF-TOP APPROACHES

For multipitch climbs, you'll typically rappel from the top of the cliff. For this kind of rigging job, you'll need a wall climber's skills—rappelling and jumaring fixed lines, managing pendulums, light hauling, rope control at hanging belays, and so forth. If you've never climbed a wall, do at least a small one before you attempt to shoot anything longer than a one-pitch sport route. If wall climbing seems like too much work, then a full-blown vertical shoot probably will be too.

Don't think that you can just throw your ropes down a major cliff in the general direction of climbers low on a route and expect to find

Opposite: **Practice on a small crag before trying to rig and shoot a major multipitch climb like this one, on the North Chasm View Wall in the Black Canyon of the Gunnison, Colorado.** JIM SURETTE

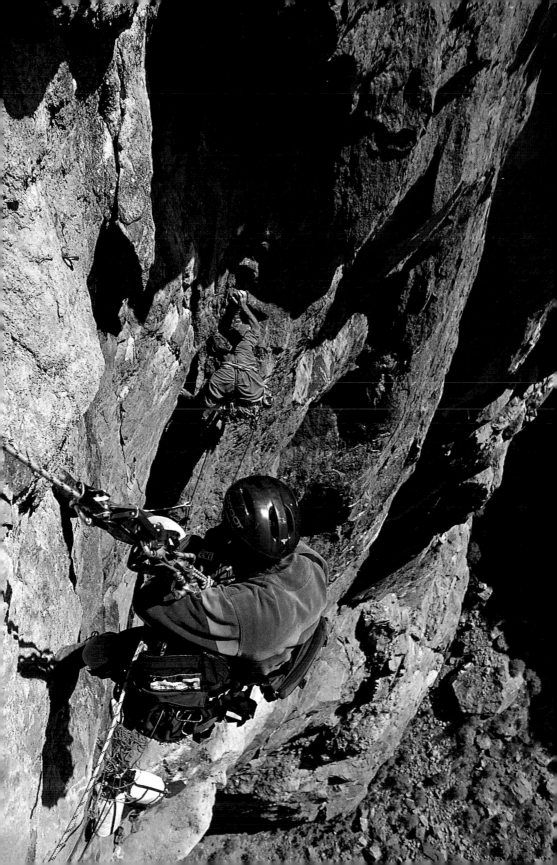

them. Shooting only the last few pitches is the safest tactic; otherwise, you'll need lots of rope and a good nose for route finding. Even if you're familiar with the cliff, things look different going down. Try to descend a route you know, preferably one with lots of fixed gear. Avoid routes with long sections of easy climbing at the top, where you'll surely get lost and where loose rock is much more likely. Don't count on swinging sideways into position once you see where you are. If the cliff is steep, your mobility out of the fall line will be minimal—near zero if the rock is smooth and crackless.

When you're getting ready to begin a descent, organize your gear well away from the cliff edge. Be delicate and meticulous. A friend and I were once starting up the Nabisco Wall in Yosemite when a photographer sent a typewriter-sized rock whizzing past our heads. I never went on a shoot with him again.

Some summit anchors are easy; others involve numerous less-than-perfect components such as skinny trees and scattered nut placements. For complicated rigs, a 50-foot length of 9mm rope can greatly simplify equalizing your anchor points.

Before you head down, make sure that you have plenty of climbing gear for directional anchors or additional rappel stations. Get all set up—attach jumars to your harness, wall-climbing style, with daisy chains, aiders, and locking carabiners, leaving them clipped to a side gear loop until you need them. Tie a beefy backup knot in the end of your rappel rope.

Lower or throw the rope carefully so it doesn't hit the climbers or knock debris off ledges, and get over the edge cleanly. Rappelling on a Gri-gri is slow and bumpy, but it's safer because it locks automatically when you let go. If you use a regular rappel device, back it up with an autoblock or prusik knot below the device, clipped to a leg loop.

Passersby may tamper with your rappel anchors while you're below. Leaving a note describing how your life depends on these lines will not ensure your safety. Consider leaving someone on top to guard the anchor. I often make a second rappel anchor a few meters down the cliff—out of reach, but in a place where I could free-climb to the top if I had to—and cinch the line down tight with a clove hitch so the tension makes it difficult to untie the summit knots. When I get back up to this clove hitch, I can inspect for signs of tampering before trusting the vulnerable anchor. Beware of leaving rigging in place overnight. Rodents love to chew through slings and rope.

A clean-running line is a must. Avoid sharp edges—pay close attention to the cliff edge, for starters—and pad the rope where contact is unavoidable. You can make good rope protectors from sections of garden hose, slit down the middle. Duct-tape them tightly closed around the rope, then tape them in place. Use two layers of hose, and offset the slits for maximum insurance. Carry the duct tape with you and use it directly on sharp rock edges lower down. Remember to clean up after yourself, even if it's dark when you jug out.

I don't like to dangle from long lengths of unanchored fixed line that can shift or rub over edges hundreds of feet above, so I often use intermediate anchors whenever it's convenient. Tie the rope in with a clove hitch or figure eight, leaving just enough slack so the new anchor shares the weight. When you return, you can inspect each rope section for signs of danger.

When descending overhanging walls, clip in to fixed gear, or place your own, to stay near the rock. It's difficult to photograph if you're spinning free in space.

If you're setting multiple ropes, the cleanest way to carry them is in prepacked rope buckets, which are easily made from stuff sacks. Tie a figure eight on a bight at the bottom end of the rope and clip this to the bucket. Flake the rope into the bucket, tie another figure eight in the top end of the rope, and clip this to the carabiner securing the bottom rope end. With this rig, you can grab a bucket, clip the top end to the new anchor or the end of the previous rope, and continue your descent without having to uncoil a rope while dangling on rappel. You can either toss the new rope, bucket and all, or rappel with the bucket and feed out rope as you go. Use the latter method in windy conditions or if the dropped bucket might hit a person or knock a rock loose. Leave the bucket at the connection point and repack it when you ascend.

I always rig with static lines. They're durable, won't rubber-band when you jumar, and won't saw across edges. If you want to buy just one static cord for multipitch rigging, a 100-meter 10.5mm (5/$_8$-inch) line is heavy but bombproof and long enough for getting well down the wall. If you have to fix a lot of rope, and especially if you have to carry it a long way, consider 9mm 60-meter lines. These ropes are also more versatile. They make good haul lines for big-wall climbing, unlike fat, long lines, which are only useful for rigging. Don't rappel with a Gri-gri on 9mm lines.

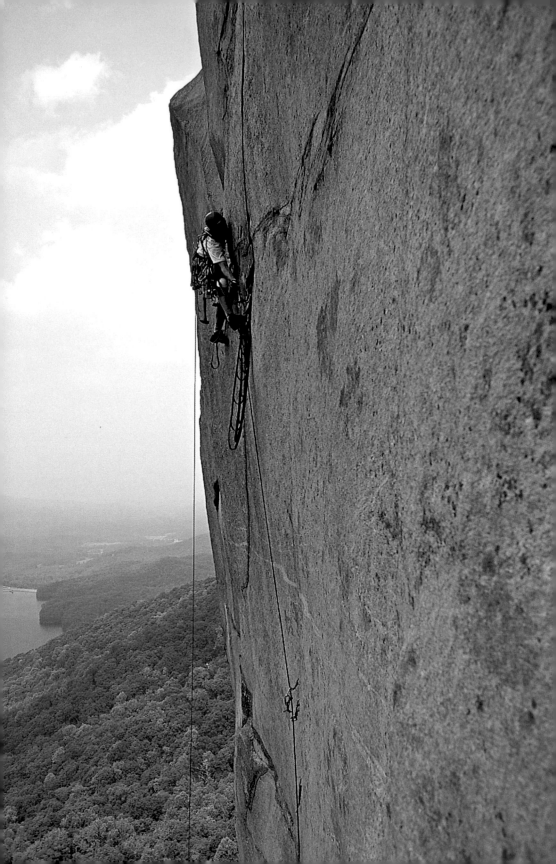

When you reach your shooting position, stop your descent, clamp your jumars on the rope, and get your weight off the rappel device. Tie a figure eight in the fixed line, and clip to it with a locking carabiner (your backup, the same as when jumaring on a wall). Undo your rappel device and set up your shot.

Don't get so engrossed in the rope management of a vertical shoot that you forget the photographic basics, such as taking time to experiment with composition. When shooting from above, you'll generally want the climber near the top of the frame so that you can make the most of the exposure below. Watch your plumb lines—when up is toward the camera, it's hard to know exactly how to orient the frame for a natural look. Usually you have several choices of perspective, but the angles in between will look awkward and tilted. If your shot includes the horizon or the vertical lines of trees or free-hanging ropes, these demand precise frame orientation.

Make sure that gear, ropes, and flapping aiders are out of your picture. Burn a few frames that include your shadow or part of your rigging, just for memories' sake, but then remember that in the best adventure climbing shots, the viewer forgets about the photographer and feels like he's there.

RIGGING ICE

Shooting ice climbing involves all the hazards of shooting rock, plus some. Ice is delicate, so icefall is a constant. Watch for fragile ice plates on the slabs at the top of the cliff, and don't kick off any snow avalanches. A particular hazard once you're over the edge is your rope breaking off icicles.

It may seem obvious, but don't head down an ice climb without crampons on your feet. You probably walked to the top without crampons, but if you go over the edge in just your boots, you'll be helpless on the ice below.

Be very cautious about ice-screw anchors. Constant pressure from your weight can compromise the security of the placement, and if conditions warm up, the screws can melt out. Use trees or rock anchors whenever possible.

Opposite: **Climbing side-by-side routes, like I did with Jeff Weathersbee in South Carolina, is one way to avoid special rigging when you're shooting a big climb.**

Ice climbing is cold, but shooting ice climbing is colder. Bring plenty of extra clothing, hand warmers, even a flask of hot tea. Hanging in your harness can impair the circulation in your legs and quickly lead to frostbitten toes. A bosun's chair will help. Remember also that ice climbs tend to be shady and dim, so you may want to load a faster film.

BE PREPARED

I know of more than one instance of climbers having to rescue their photographer, who failed to realize that he, too, was on a big wall and subject to storms, hypothermia, and dehydration. Bring food, water, and proper clothing.

Vertical shoots are hell on camera gear, so your camera bags must be durable and protect their contents. If the shoot is more than just a small-crag deal, I usually rappel with a rucksack that includes my camera bag, food, water, and storm clothes. The camera bag comes out once I get in position.

It's better to bring too little camera gear than too much. You want to be mobile. Sharpen your results with skill and creativity, not gimmicky equipment. Zoom lenses simplify on-rappel shoots. They save a lot of moving around to get the right composition and reduce lens changing and the attendant risk of dropping something. I seldom shoot with anything longer than an 85mm lens on rappel, but I always have a wide-angle lens, 24mm or better.

GEAR CHECKLIST FOR CLIMBING PHOTOGRAPHY

- Camera(s), lenses, motor drive, flash, filters
- Extra batteries
- Film
- Pocket camera
- Tripod and cable release
- Camera bag(s)
- Ziploc bags and hand warmers (cold weather)
- Rucksack
- Food, water, weather gear
- Stick clip (rigged with tie-off loop)
- Bosun's chair
- Boom or stilts
- Anchor rope (50 feet), rope guards, duct tape
- Static line(s)
- Rope buckets
- Helmet, harness, rock shoes
- Chest harness
- Rappel device, rappel backup, Gri-gri
- Locking carabiners
- Jumars, daisy chains, aiders
- Rappelling rack—nuts, cams, etc.
- Carabiners, slings, quickdraws
- Rope-solo gear
- Umbrella and shock cord
- Soft-box
- Light meter
- Changing bag

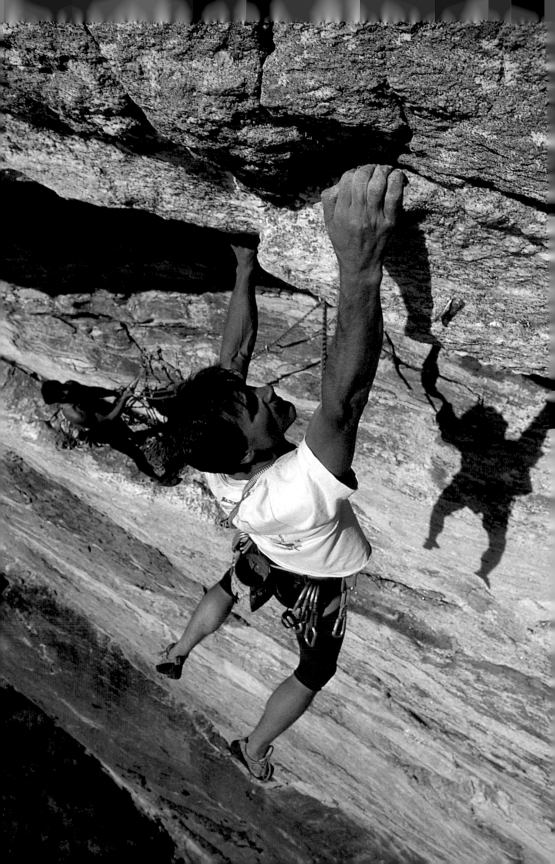

SHARING YOUR WORK

Taking good photographs is satisfying, but photography is a form of communicating with others, not just yourself. Working at and improving your photography can be a lifelong project, and you're more likely to stick with it if you get some exposure and recognition, at least from your friends.

There's nothing like having a photo published to get you excited to continue and improve. There's a lot of competition, but new photographers get published every day.

Opposite: **Arno Ilgner and Doc Bayne on Whitesides Mountain, North Carolina.**

CHAPTER 10

TELLING THE STORY

Try to imagine how you'll show your photos once you get them. If you're shooting exclusively to get that killer action shot that'll land you your first cover and make you rich and famous, the day's little details can fall by the wayside. If you plan a slide show, however, document the whole experience—packing gear, hitting the road, late-night driving, the people, the rest days. Get images that tell the complete story.

Editing

Even the most polished pros take bad pictures—lots of them. What makes them pros is that they know enough to send these images directly to the garbage can.

Edit your photos ruthlessly. In five years you won't care a whit about old, bad mountain scenics, but you'll be glad you saved those of partners and other memorable people. Otherwise, toss anything that's out of focus or poorly exposed, making mental or written notes if you see a recurring problem. Next, get rid of poorly composed, bland images. Keep only those that somehow "sing" a little. A productive editing session requires a small light box and a good loupe (see chapter 3).

Storage and Filing

Once I've edited, I stamp a roll number on each keeper slide and file the rolls chronologically in plastic loose-leaf pages (each the size of my light box) that hold twenty mounted slides and fit in a standard notebook. My indexing system is simple, but it works: I make notes of what's on each roll and enter these into a simple text document on my laptop. When I'm trying to find something, I do a word search for "helmets," "Zion," "stupid carabiner tricks," or whatever. If you prefer, you can purchase specially designed software programs that will organize all

Right: **Stacey Shaw toes the line between footwork and philosophy.**

Opposite: **Just how big** *were* **those haul bags?**

Start of the Phoenix Bouldering Contest, 1997.

your photographic data, print labels for your slides, and perform other useful functions.

Slide Shows

Give slide shows regularly, if you can find someone to watch. You'll glean useful clues about how your work affects others and gain valuable public-speaking practice in case you want to go pro after a successful expedition or a particularly good summer of shooting.

If you thought ahead while you were on location, putting together an interesting slide show will be easy. You'll have good shots of home departure, destination arrival, camp, people, rock, the gear, animal visits, the big events, trip's end, and so forth. You will have mixed up your compositions, shooting long, medium, and close, and made sure

that your camera was handy to catch those precious moments, like the time your partner accidentally ladled refried beans into his chalk bag or botched another French phrase while talking to that pretty shopkeeper. Never miss an opportunity to shoot funny images. No matter how serious you are about your work, humorous slides will invariably be the crowd favorites, regardless of their artistic merit.

In part two of an excellent series that ran in *Climbing* magazine (June–September 1992), eminent boulderer, skilled photographer, and hilarious slide-show presenter John Sherman included a superb primer on slide shows. I borrow liberally here: Mix talking with music. People want to hear the tales, but unless you're really good, after a while you'll just be droning on. One good way to design a music section is to play the music you want to use while running an empty slide projector set at a fixed rate—say, six seconds per slide. At each new frame, make a written note of a mood the music evokes—grace, danger, whatever. When you've finished the music, go back through the list and find a slide to match each note. Repeat for each music portion of your show. Slide shows shouldn't exceed an hour, and each slide should be shown for ten seconds maximum. When the lights come up, your friends should still be wanting more. The same applies for a show you give professionally.

Never miss a chance to capture your friends in those special funny moments. Here, Bob Ordner has fallen and he can't get up in Sandrock, Alabama.

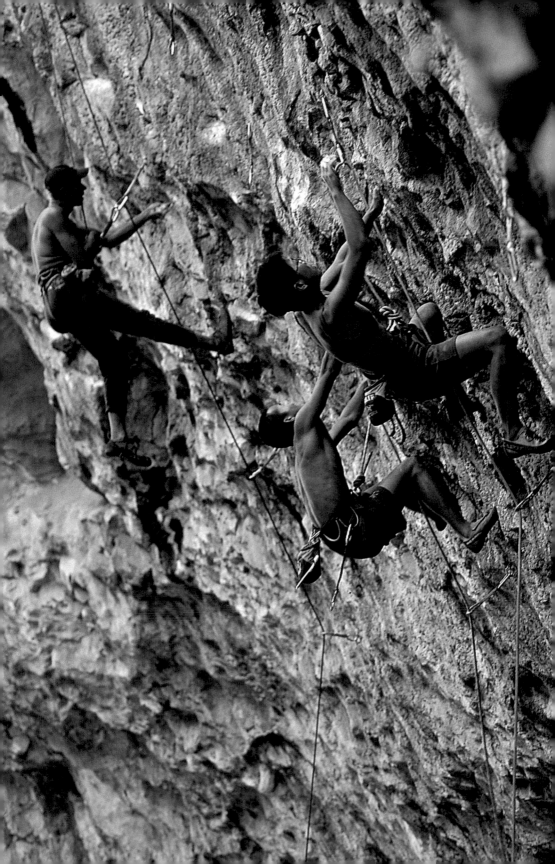

CHAPTER 11

SELLING YOUR PHOTOGRAPHS

Let me say right away that I don't recommend trying to make a living selling climbing photography. The market is small and competitive, and finances will pressure you into shooting subjects far from where your heart lies. To pay the bills, you'll start shooting for commercial, mainstream, or some photo editor's tastes—an instructive exercise, but a destructive habit. It's better to be a serious amateur, with the money you make on photos earmarked for fun.

That said, at this book's publication (2000), rates for photography in American climbing magazines and major equipment catalogs were $300 to $600 per full page. Climbing images used in mainstream publications (ad agencies often spot the photos in climbing magazines) pay much more. European climbing magazines pay significantly less, especially after the checks go through taxing and currency exchange. Regardless, a few published photos can pay for your camera or a year's worth of film and processing. It's worth a try.

Before you submit photos to any magazine or catalog, take a careful look at the editorial style. Are they running only images of known hotshot climbers? Are they into dreamy, pastel-colored palettes, or deep blacks and angular graphics? Gritty, authentic-looking shots, or posed perfection in the warmest afternoon light?

A call to the photo editor won't hurt. Keep your conversation short, but introduce yourself, tell a little bit about your work, and ask for photographers' guidelines and a needs list of upcoming subjects or destinations.

Opposite: **Was the crag too crowded for your taste? Seize the moment, don't just leave in disgust.**

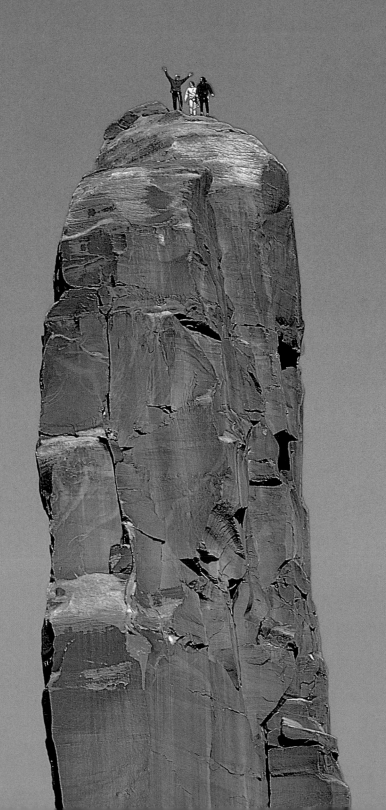

Never submit weak shots, even if you have subjects the magazine is looking for. These won't be picked, and they'll only ensure that your name is associated with lame submissions. It's better to submit great shots of other subjects.

The random photo gallery sections of magazines are the most competitive of all. You'll increase your chances of getting published if you can hook up with a writer and propose a complete article—both photos and text.

When you submit, your package should be professional looking. Send your slides in plastic slide sheets, and make absolutely sure that each mount displays your name and either the complete caption information or a reference number for a caption sheet. Include a delivery memo that has all your contact information—name, address, phone number—the number of images sent, and the subject of the images. Captions can also go on this memo. It's usual to have a legalities section in fine print at the bottom of the memo, stating the magazine's or company's responsibilities for care of the images, the cost for lost images, and so forth. Consult a current freelance photographer's handbook for sample memos and other submission guidelines.

Most professional climbing photographers submit original transparencies. Although duplication technology has advanced considerably in the last five years, most photo editors insist on originals for publication, and if one of your dupes is competing with someone else's original, the editor will likely use the original she has in hand rather than calling you and asking for yours. If you do much professional work, get in the habit of making in-camera dupes—shooting multiple frames of all your promising images right on location and keeping the extras as backups in case slides get lost or damaged. If, through real negligence, a company loses one of your images, a $1,500 charge is standard.

Unless you've agreed otherwise, include an self-addressed stamped envelope with your submission. It's up to you which shipping service to use. Some pros use regular, uncertified first-class mail, but this provides no record that you've sent the images—something you'll need if you have problems getting them back. Federal Express, UPS, and the U.S. mail all provide various receipt services.

Opposite: **Kennan Harvey, Irene Boche, and Steve Cater enjoy the January sun at the summit of Zeus.**

CONCLUSION

Well, there you have it, a how-to manual on the esoteric art of climbing photography. There are many secret techniques not covered here and innovations still to be discovered. Study the photography in all venues—coffee-table landscape books, fashion magazines, *Sports Illustrated*. Every few years, some new shooter bursts on the scene with a vision that makes all the old hands feel—well, old.

Copying, sharing, experimenting—it's all part of what makes being a climbing photographer ever-changing and fun. There are still new forms of vertigo-inducing, palm-sweating, awe-inspiring climbing photos to be taken out there, so, as my old boss, photographer Michael Kennedy used to say, "Happy hunting."

The Needles, Canyonlands National Park, Utah.

RESOURCES

BOOKS

An incomplete list. These titles I've found particulalry inspirational or standard-setting.

Carter, Simon. *Rock Climbing in Australia.* New Holland, 1998.
A beautiful perspective on the orange rocks and green jungles "Down Under," by one of the country's best.

Dumais, Richard. *Shawangunk Rock Climbing.* Chockstone, 1985.
One of the best efforts of its day. (1985). Superb but out-of-print picture book on the most famous climbing area in the East, the Shawangunks of New York. Features the work of many talented photographers.

Epperson, Greg. *Rock Prints: A Collection of Rock Climbing Photography.* Self-published, 1998.
A gritty, artsy black-and-white treatise photographed and produced by the great enigmatic pioneer of rock-climbing photography. A study of texture and subtleties, this is Epperson's first book—may there be more. Though Greg doesn't say this, I'm quite certain many of the images were originally shot on color film, a testament to modern digital technology.

Mathis, Peter. *Sportklettern in der Alpen.* Kompass, 1996.
German text. Spectacular rock-climbing shots from the rock of the high Alps. This book is an example of where you can go after "ground school" on the smaller crags—the shots here represent monumental efforts in "getting into position."

Rowell, Galen. *Galen Rowell's Vision: The Art of Adventure Photography*. Sierra Club Books, 1993.

This is the one how-to book in my list, a collection of articles from Rowell's column in *Outdoor Photographer* magazine. Though Rowell is an accomplished Yosemite climber from the golden age, he's now best known for imagery of cultures and wildlife and landscapes—including mountains—from exotic corners of the globe. The book is full of helpful hints about modern electronic cameras, flash, films, filters, digital imaging, travel, and other technical, stylistic, and philosophical matters relevant to outdoor photographers.

Sherman, John. *Stone Crusade; A Historical Guide to Bouldering in America*. American Alpine Club, 1999.

The definitive historical bouldering guidebook to the United States, and also an unmatched collection of black-and-white bouldering photography—some of my favorite black-and-white work in all of rock climbing.

Glowacz, Stephan, and Uli Wiesmeier. *Rocks around the World*. Sierra Club, 1989.

Wiesmeier is one of my favorite European photographers—technically precise, imaginative, and with a great sense of humor and of culture. This book chronicles selected stops on Glowacz's journeys from Europe and England to Japan, Australia, and the United States.

Zak, Heinz. *Rock Stars*. Rothar, 1998.

Action portraiture of the world's best rock climbers by one of the master photographers. Great light, great faces, and impressive, gymnastic climbing.

MAGAZINES

All kinds of companies—from those that make climbing gear to those that make computer software or sell insurance—use rock-climbing photographs in their ads. Peruse magazines and catalogs for promising buyers.

Editorial photography is another place to start. The market is small and you won't get rich, but your work will be used more truly for what it is, not what it might sell. Below is a list of some of the better

climbing magazines around the world. To submit work, first contact the editorial office and ask for contributor's guidelines, which should tell you the magazine's rates and protocol for submissions.

Climbing (USA)
 0326 Highway 133, Suite 190
 Carbondale, CO 81623
 phone: (970) 963-9449
 climbing@climbing.com

 Hard-core rock, ice, and mountaineering.

Rock & Ice (USA)
 603 S. Broadway, Suite A
 Boulder, CO 80303
 phone: (303) 499-8410
 editorial@rockandice.com

 Hard-core rock, ice, and mountaineering.

Rock
 c/o Wild Publications
 PO Box 415
 Prahran, VICT 3181
 AUSTRALIA
 fax: 011-61-3-9826-3787
 rock@wild.com.au

 Hard-core rock climbing, mostly Australia.

On the Edge
 PO Box 21
 Buxton, Derbyshire SK17 9BR
 UNITED KINGDOM
 fax: 011-44-1536-52-2621
 publishing@greenshires.com

 Hard-core rock climbing. British/European slant, but often featuring American areas.

Non-English-Language Magazines
Rotpunkt
Postfach 18 28
D-70708 Fellback
GERMANY
fax: 011-49-711-957-9759
rotpunkt@rotpunkt.de

Hard-core rock climbing. "European newsy," but with occasional American articles.

Klettern
Zieglergasse 11
D-70372 Stuttgart
GERMANY
fax: 011-49-711-954-7928
redaktion@klettern-magazine.de

Hard-core rock climbing and mountaineering. More photography and alpine rock than *Rotpunkt*.

Alp
Vivalda Editori
srl via Invario 24/a
10146 Torino
ITALY
vivalda@vivalda.com

Mountaineering, climbing, skiing, mountain cultures—not much rock climbing.

Grimper
6, rue Irvoy
38027 Grenoble Cedex 1
FRANCE
fax: 011-33-4-7670-5412
info@grimper.com

Hard-core sport and crag climbing and European competitions.

Roc 'N Wall
 6, rue du Lietenant Chanaron
 38000 Grenoble
 FRANCE
 fax: 011-33-4-7688-7570
 rocnwall@glenat.com

 Hard-core sport and crag climbing and competitions. Perhaps the
 most American-friendly of the French magazines.

Vertical
 6, rue du Lietenant Chanaron
 38000 Grenoble
 FRANCE
 fax: 011-33-4-7688-7589
 concerto@alpesnet.fr

 Rock climbing, mountaineering, ski mountaineering.

Desnivelle
 c/San Victorino No. 8
 28025 Madrid
 SPAIN
 fax: 011-34-9-1360-2264
 desnivel@desnivel.es

 Rock climbing and mountaineering, leaning toward the adventurous.

INDEX

Page numbers in italics refer to photographs.

Achey, Jeff, *3, 36, 91*
Ancient Art Spire, Moab, Utah, *54*
Argentiere Glacier, Chamonix,
 France, *53*
Arizona Highways, 42
Aspen, Colorado, *86*
Autoexposure, 49–50

Bass, John, *46*
Baxter's Pinnacle, Tetons, Wyoming, *74*
Bayne, Doc, *71, 95*
Black Canyon of the Gunnison,
 Colorado, 33
 North Chasm View Wall, *86*
 Painted Wall, *6*
Blower, compressed-air, 30
Boche, Irene, *6, 103*
Books, 106–7
Booms, 34–35, *35, 36,* 38–39
Bosun's chair, 34
Brush, camel-hair, 30
Burcham, John, *35, 36*

Camera(s)
 buying tips, 11
 introduction to, 2–3, 5
 pocket, 5–6, *5, 6,* 8

SLR body of a, 9–10, *9*
Camera bags/pouches/cases, 30–31,
 31, 33, *33*
Camera care in extreme environ-
 ments, *79, 80*
 cold, 80–82, *81, 82*
 dust, 78
 impact, 78
 introduction to, 78
 travel, international, 82
 water, 79–80
Canyonlands National Park, Utah, *15*
 Monster Tower, *42,* 77
 Needles, the, *105*
 North Six Shooter Peak, *41*
 Washer Woman Tower, *79*
 Zeus Tower, *1, 103*
Cater, Steve, *103*
Chace, Monika, *42,* 77
Chamonix, France
 Argentiere Glacier, *53*
Climbing
 camera care in extreme environ-
 ments, 78–82, *79, 80, 81, 82*
 challenges of, 77, *77*
 rigging, 83, 85–86, *86,* 88–89, 91–92, *91*
Climbing, *72, 99*

Close-ups, 66, *68, 71*
Cold, camera care and, 80–82, *81, 82*
Composition
 depth of field, 62, *62,* 64
 introduction to, 56
 mood, 56–58, *57, 58,* 61–62, *61*

Depth of field, 62, *62,* 64
Diamond, the, Rocky Mountain
 National Park, *18*
Displaying your work, *95*
 introduction to, 95
 selling your photographs, 101, 103,
 101, 103, 107–10
 showing your photographs, 96–99,
 97, 98, 99
Dr. Rubo's Wild Ride, Sedona,
 Arizona, *36*
Dolomites, Italian, *6*
Donahue, Topher, *41*
Dragon Park, Nashville, *17*
Dust, camera care and, 78

Editing your photographs, 97
El Capitan, Yosemite National Park,
 California, 35, 58
Eldorado Canyon, Boulder,
 Colorado, *17*
Epperson, Greg, 14, 35
Equipment. *See* Gear, climbing;
 Gear, photographic
Exposure, *49*
 auto-, 49–50
 introduction to, 48–49
 metering, manual, 50–55,
 51, 52, 53, 54

Filing and storage of your pho-
 tographs, 97–98

Film
 introduction to, 23
 ISO numbers, 23–24
 Kodachrome vs. Fuji Velvia, 24, *25*
 loading, 25
Filters
 introduction to, 25
 polarizing, 26, *27*
 skylight, 25–26
 variable neutral-density (ND), 26–27
 warming, 26
Fisher Towers, Utah, *20*
Flashes, 28–29, *28*

Galen Rowell's Vision, 26–27
Gear, climbing
 booms, 34–35, *35, 36,* 38–39
 bosun's chair, 34
 checklist for, 93
 introduction to, 34
 stilts, 34–35
Gear, photographic
 blower, compressed-air, 30
 brush, camel-hair, 30
 camera bags/pouches/cases,
 30–31, *31,* 33, *33*
 cameras, 2–3, 5–6, *5, 6,* 8–11, *9*
 checklist for, 93
 film, 23–25, *25*
 filters, 25–27, *27*
 flashes, 28–29, *28*
 introduction to, 1
 lenses, 13–15, *15,* 17–18,
 17, 18, 20–21, *20*
 lens hoods, 27–28
 light box, 30
 light meters, 28
 loupe, 30
 tripods, 29–30, *29*

Harvey, Kennan, *1, 103*

Ice, rigging, 91–92
Ilgner, Arno, *71, 95*
Impact, camera care and, 78

Jack's Canyon, Arizona, *51*
Joshua Tree National Monument, *44*

KEH Camera, 11

Laflamme, Jason, *13*
Lago di Garda, Italy, *46*
Landscapes, 65–66, *67, 68*
Leas, Nancy, *49*
Lens(es)
 focal length of, 13–15, *13,
 15, 17, 18, 20*
 introduction to, 13
 speed of, 17–18
 systems, 21
 zoom, 18, 20–21
Lens hoods, 27–28
Leonard, Scott, *66*
Levin, Steve, *71, 77*
Light
 mountain, 44–46, 48
 time of day and, 42, *42*, 44,
 44, 45, 46
Light box, 30
Light meters, 28
Loupe, 30
Luebben, Craig, *41*

Magazines, 107–10
Metering, manual
 backlighting and, 54–55
 introduction to, 50
 moonlight and, 55

snow and, 53–54, *53*
techniques and tricks, 51–55,
 51, 52, 53, 54
Meters, light, 28
Moab, Utah, *13*
 Ancient Art Spire, *54*
 Sorcerer, the, *41*
Monster Tower, Canyonlands
 National Park, Utah, *42, 77*
Mood, *57, 58, 61*
 general rules, 57–58, 61–62
 introduction to, 56–57
Motion, *66*, 71–72, *72*

Nabisco Wall, Yosemite National
 Park, California, 88
National Geographic, 2
Needles, the, Canyonlands National
 Park, Utah, *105*
North Chasm View Wall, Black
 Canyon of the Gunnison,
 Colorado, *86*
North Six Shooter Peak, Canyon-
 lands National Park, Utah, *41*

Ordner, Bob, *99*
Outdoor Photographer, 27

Painted Wall, Black Canyon of the
 Gunnison, Colorado, *6*
Paradise Forks, Arizona, *57*
Pegg, Dave, *86*
People skills, 75
Phoenix Bouldering Contest, *98*
Popular Photography, 11
Portraiture, 68, 71, *71*
Posing, 72, 74, *74*
Powell, Kevin, 48
Redstone, Colorado, *66*

Resources
 books, 106–7
 magazines, 107–10
Rigging
 ice, 91–92
 introduction to, 83, 85
 multipitch climbs and cliff-top
 approaches, 86, *86*, 88–89, 91, *91*
 preparedness, 92
 sport climbs and rigging from
 below, 85–86, *86*
Rocky Mountain National Park
 Diamond, the,*18*
Rowell, Galen, 26–27, 30

Sandrock, Alabama, *99*
Sedona, Arizona, *35*
 Dr. Rubo's Wild Ride, *36*
Selling your photographs, 101, 103,
 101, 103
 magazines, 107–10
Seyfurt, Julie, *74*
Shaw, Stacey, *97*
Shawangunks, New York, *15*
Sherman, John, *99*
Showing your photographs, *97, 98, 99*
 editing, 97
 introduction to, 96
 slide shows, 98–99
 storage and filing, 97–98
Shot types
 close-ups, 66, *68, 71*
 landscapes, 65–66, *67, 68*
 motion, *66*, 71–72, *72*
 people skills, 75
 portraiture, 68, 71, *71*
 posing, 72, 74, *74*
Slide shows, 98–99

Sorcerer, the, Moab, Utah, *41*
Sports Illustrated, 104
Stableford, Tyler, *72*
Stilts, 34–35
Storage and filing of your
 photographs, 97–98
Syonnott, Mark, *6*

Tetons, Wyoming
 Baxter's Pinnacle, *74*
Travel, camera care and interna-
 tional, 82
Tripods, 29–30, *29*

Vail, Colorado, *72*

Wald, Beth, *61*
Ward, Susan, *36*
Washer Woman Tower, Canyonlands
 National Park, Utah, *79*
Water, camera care and, 79–80
Weathersbee, Jeff, *91*
Whitesides Mountain, North
 Carolina, *62, 95*
Whitford, Jo, 14
Whitney, Mount, California, *45*

Yosemite Falls, Yosemite National
 Park, California, *5*
Yosemite National Park, California
 El Capitan, 35, 58
 Nabisco Wall, 88
 Yosemite Falls, *5*

Zak, Heinz, 74
Zeus Tower, Canyonlands National
 Park, Utah, *1, 103*
Zion National Park, Utah, *3*